Typo Graphics

The art and science of type design in context

Ivan Vartanian

RotoVision

Previous Page: Designed by Tsuyoshi Nakazako of the design duo +ISM. Each letter and number has been given an equivalent dingbat of a prosthetic appendage (perhaps intended for an android in need of replacement parts).

A RotoVision Book
Published and distributed by
RotoVision SA
Route Suisse 9
CH-1295 Mies
Switzerland

RotoVision SA
Sales, Editorial & Production Office
Sheridan House
112–116A Western Road
Hove, East Sussex BN3 1DD, UK
Tel: +44 (0)1273 72 72 68
Fax: +44 (0)1273 72 72 69
Email: sales@rotovision.com
www.rotovision.com

Conceived, designed, and produced by
Ivan Vartanian, Goliga Books, Inc., Tokyo, Japan

Manufactured by in China
by Everbest Printing Co., Ltd.

ISBN 2-88046-769-1
10 9 8 7 6 5 4 3 2 1

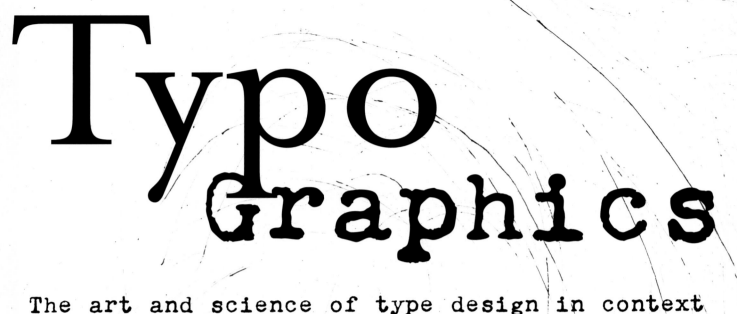

Typo
Graphics

The art and science of type design in context

Ivan Vartanian

TABLE OF CONTENTS

INTRODUCTION

SCREEN

DIMENSION

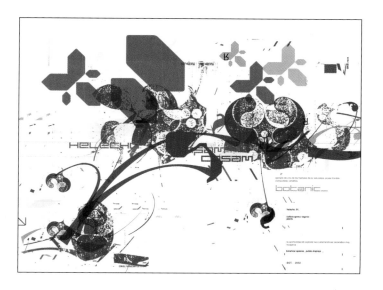

Type In Context

How does culture influence our understanding of type? What is the purpose of articulating the culture-specific use of type? How do the form and function of type change depending on other contexts, such as illustration, dimensional typography, and screen display? Finally, what does the reader bring to text and type?

East meets West, East versus West

The idea of looking at typography within a cultural context began when I first saw typography out of context. That is, living and working in Tokyo, Japan, for the past six years, I have become accustomed not only to Japanese writing systems, but also to the conventions of how type is set and read in English. Before even considering the enormous differences in grammar, idiom, semantics and gender, written Japanese vastly differs from any Western language. For instance, Japanese is traditionally set vertically (but can also be set horizontally), the written language uses a combination of three different systems (one of which is *kanji*, or Chinese characters), and it reads both from right to left and left to right. In the process of mastering written Japanese, my native language, English, began to seem foreign. Or, rather, its peculiarities became apparent.

This process of viewing the familiar from a new perspective is an approach I have tried to recreate in this book. Personally, this has been the most powerful tool to understanding the limitations imposed by convention and the extent to which meaning is encoded in the type I had always mistakenly considered a "neutral" element. Therefore, seeing type set in English in the same context as Japanese was one of my most edifying experiences when acclimatizing to life in Japan. Generally speaking, successful combinations of any Western language with written Japanese are rare. Such exemptions only seem to reinforce the mishmash nature of all other instances. Examples of mono-spaced lettering, poor leading and other such violations are the norm. But then, these conventions are, after all, just a gauge of a reader's idea of how type should look. Also, seeing how Japanese is laid out on the page was another revelation. Compared to type setting in the West, margins are becoming a thing of the past here. Also, what Western readers would consider "fine print," for example, is generally the size in which most Japanese magazines set their body copy.

With everything that goes on with layout and organization of text, it starts to become clear that the type that is used as the medium for all these functions is itself integral to effectively render the

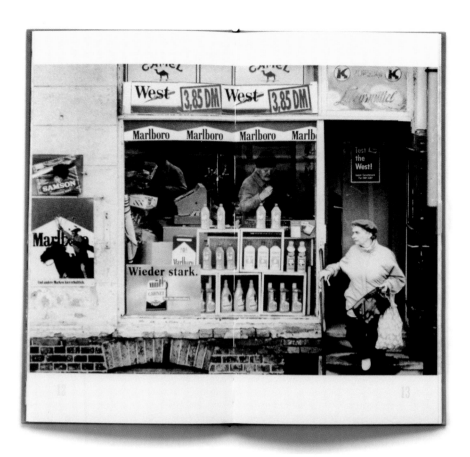

text. Type is not only a matter of design but also influences how reading happens. In other words, type is context specific. Type, once a neutral element, has become a loaded issue.

Witnessing this on such a vast level with a dramatic example like Japanese was a good opportunity to start thinking about type as context-specific constructions. Being in Japan for so long, and reading and translating between the two languages, I have become acutely aware of how the very same letterform can signify one thing in one context and another in a different context. For example, for a Western reader, a Chinese character (or any foreign letter or character) is not totally devoid of meaning, as they may identify with its graphic form. So the character for "love" (page 009) would not convey its meaning to a Western audience, but as a graphic it may contain a significance of a very different nature.

The reverse is also true. Looking at English plopped into a Japanese context is similarly meaningless and in that moment the word (though it may be an actual English word) becomes simply a graphic form. English set following Japanese typesetting conventions makes the type look cumbersome and awkward. The manner in which layout is handled determines the standards of typesetting. But the type itself has a symbiotic relationship with the layout.

A typographer anticipates these standards of leading, line width and other general conventions with which most readers are accustomed. The type itself is designed with all this history in mind. In this sense, a font is designed within and for a specific, anticipated context. With the proliferation of typefaces and the ease with which designers can customize them, it has become much easier to see the contexts for which type functions. Becoming aware of this problematic function of type in a concrete way—seeing English within an Asian context—I set about trying to look at type within other contexts, which have formed the various sections of this book. The first of these sections, Locale, specifically addresses the issue of cultural influence on type, its form and its usage.

Glyphs and Other Such Oddities

In contrasting the alphabet with *kanji*, the differences in visual weight and complexity of organization and composition are apparent. This was where looking at letterforms as pure graphic forms began for me. As seen from a distance, for example, alphabet letters are easier to read since the strokes are fairly limited in number and simple in form. *Kanji*, on the other hand, has many more strokes and comprises multiple, nested constructions. When viewed up close, however, characters convey

GÜNTER GRASS

Previous Page: A spread from *Ein schnäppchen Namens DDR*, as typeset by Claus Lorenzen. With the unification of East and West Germany, Grass maintains that the might and deluge of the West's economy ousted the East's economic system, its way of life and its people. Advertising billboards, the herald of life from the West, are disturbingly out of place with the homely atmosphere of the East German tobacco stand.

CHINESE CHARACTER FOR "LOVE"

Opposite Page: Japanese has appropriated the Chinese writing system of pictographs, known as *kanji*. There are about 10,000 characters in everyday use in contemporary written Japanese. In contrast, written Chinese uses well over 30,000 characters, many of which do not have the simplified or modernized form of their Japanese counterparts. The complexity of some characters makes writing them accurately a challenge, even for native speakers.

meaning with greater immediacy than their alphabet counterparts. Not unlike hieroglyphics, *kanji* carry meaning on a multitude of levels, both semantic and graphic, as well as a multiple set of phonetic readings. (Apart from this, Japanese still avails itself of two other writing systems in addition to an auxiliary use of the alphabet.) Also, in Japan, where the tradition of calligraphy enjoys a long and popular history, the rendering of character and letterforms into graphics is quite common (see Tycoon Graphics, page 030).

There is far less distinction between type and graphics in a language that uses pictographs. Again, the lesson of the East comes into play as illustration becomes the basis for a new typeface and vice versa, as exemplified by the work of Bionic Systems (page 074). They seamlessly mesh type into their illustrations using contour drawing. In other words, the same line element used to create type is also utilized for generating the smooth outlines of their drawings. Therein, the forms are all given the same visual weight. This has the strange effect of making graphics become legible entities themselves.

Perhaps logos and logotype best exemplify the fused nature of type and illustration. Logos and logotype incorporate a readily identifiable design. Exposure to *kanji* and their function as pictographs and ideographs attunes a reader's awareness of the inherent graphic quality of letterforms. Thus came about the section dealing with typography and its relationship to illustration—a variant of which is logotype, where the letterforms themselves become a discrete block. An entire word or even series of words can then function not unlike *kanji*. Think of the words "sex" or "love" or, tellingly, expletives. The reader's eye reads, scans and picks up a block of letters as a discrete unit. In this way, words written with an alphabet can have a similar graphic value and function as *kanji*. (This is not always the case, however. Longer and more abstract words such as "amalgam" or "symbiosis" probably require comparatively more processing time.) The entire assembly acts as one unit—legible and laden with meaning. The design duo +ism addresses this specifically in their font Akronymx (page 155). They deal with the whole idea of copyright-controlled wording. What has remained of the public domain is gradually being sectioned off and regulated: the lexicon. Part of this is the graphic form, which is integral to the brand's identity.

Reading in the Dark

The individual roles of graphics and text are becoming ambiguous. Simple examples of this development are icons used in website interfaces. Through their widespread adoption, the graphic element eventually takes on a standard meaning and

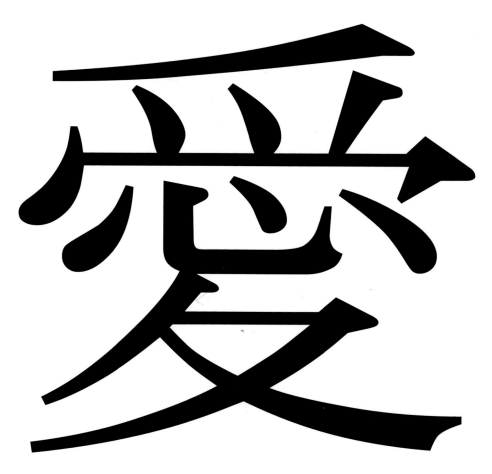

thereby adds itself to the visual lexicon. The changing demands of Internet, the commodity-nature of information, and high-speed transmissions, also bring something to our understanding of type and its form.

For many, the computer screen outranks the printed page, in terms of time spent being read. Accordingly, type that is suitable for screen display is certainly different from lead type. For example, the screen is a light source; this influences how the weight of the type is seen. Margins, leading and letter spacing are as outmoded as 5 1/4-inch floppy disks. One of the most pressing issues for typographers designing for the computer screen (or websites) is maintaining legibility while using extremely small type (while still retaining the same letterforms). Bitmap fonts have been the solution until now. Built on an extremely limited grid (page 164) the letters are no longer continuous strokes but, rather, filled-in dots on a 5-by-7 or 3-by-5 grid. Perhaps, these explorations brought about by type's limitations will have their influence on type in general.

Apart from the computer screen, devices such as hand-held MP3 players, mobile phones and such, all have screens that need to optimize the efficient use of type. There is a design for this as well! Granted, book-length texts are not read on these LCD displays (which generally lack back-lighting), but as these small, battery-operated entities

multiply, user-interface becomes quite an issue. What, then, becomes the norm for reading when a growing number of individuals are prefering to read from a screen rather than a printed sheet?

Another form of screen is found in theaters. Oddly enough, the title sequences of movies may be the best opportunity to see the poignant balance between type and image. Generally, in this case, the type is moving within some equation relative to the moving image. The examples assembled in the Screen chapter (see page 092) are all from major Hollywood films, demonstrating the widespread exposure of innovative type usage to mass audiences.

In several instances, I came across the work of designers and typographers who had experimented with the three-dimensionality of type. Some of these have been assembled into the section "Dimension." What would Helvetica be like as architecture, ponders Büro Destruct (pages 144–145)? The group Closefonts tries to see what "Q" would look like as a transparent film stretched out like a soap bubble (page 133). The principle lesson learned from these forays is the use of space, and thinking of the visual plane in terms of a spatial zone. The design group Norm makes use of this when dissecting letterforms, investigating the air around a letterform as much as the form itself.

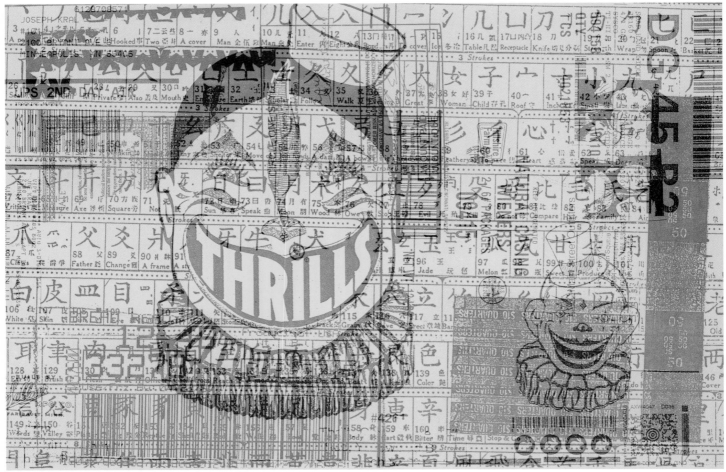

Bunnypack

Multi-tiered graphics by Test Pilot Collective designer Joe Kral.
The foreground is a hotch-potch of found items of printed
matter. In the central graphic a chart of Chinese characters is
overlaid with a sample of the designer's own typeface, laden
within the grimace of the retro-styled carnival character.
Similarly, the other compositions result from tampering
with the found printed matter.

A Case of Mistaken Identity

In large part, the individual selection of work that appears in this volume all revolves about one central concern: How does working with type precipitate new design (even if the end product is devoid of typographic matter entirely)? In this book, the main criterion for selecting work was to look for designers who have created new graphic design through working with typography and type design.

Within the vast and amorphous soup of typography available to designers, there is a whole new set of questions that seem oddly similar and germane to concerns regarding good design in general: problem solving, economy, and creativity. Within the seemingly greater freedom, we find that our choices, which we thought might have been infused with such liberty, are now, in fact, limited; our vision compartmentalized by such things as standard, or familiarity, or the distinctions we make between display type and reading type, or what we deem to be legible. So the interesting challenge facing the world of typography now is to articulate all those pre-cognitive assumptions that have been programmed into both designers and readers. The function of this book is to help shed light on one aspect of this sort of pre-cognitive

decision-making. That is, to articulate and visualize the context within which we work, setting the scope and barrier.

Looking at type from a contextual perspective then has several layers to it. Are we dealing with a discrete language? Word chunks? Or, individual letterforms? In which case, our pre-cognitive digestion of those letterforms is done with a set of enzymes that are, for better or for worse, culturally specific. The purpose of this volume is to bring some awareness to this context-specific aspect of type. I was initially fearful that designers themselves would rather not be categorized as I have organized the materials of the individual case studies of this volume. As a disclaimer, let me just add for the purpose of providing examples, that the contributors have provided certain types of materials to me. Pointing out and describing this cultural relevance, and its prevalence in the realms of type as well, is one of the central concerns of this volume.

As an editor, I found myself mostly trying to mask the seams that would reveal my own presence in the publications in an attempt to create a sense of objectivity through detachment. In the process, style and all such personal markings get tossed out the window. Ultimately, however, the processes of

selection and assembly are no less devoid of personality. What I have found with the influx of new typefaces has been a relief in most cases. Seeing designers create letters that are decidedly specific to purpose allows for greater self-expression, no doubt. But this is not so simple. Words and thoughts are now closer to the people who write and utter them. What's said is said by a person—the ideas and words don't exist separately from the mind or heart that thought them up. From a critical standpoint, this is the central issue for new typefaces that are cropping up all the time. This gets paralleled in the typography itself, which is loaded with character.

The point is that a response is generated that is context-specific. Not unlike an Emersonian text, the reader is called upon all the more to remain aware of what is brought to the text in order to "complete it" in reading. Acute awareness of these issues is the final context I'd like to tease out: we ourselves are our own context.

Glossary of Japanese Terms

Beginning around the third or fourth century AD, migrant Chinese and Koreans first brought Chinese characters to Japan. These pictographs and ideographs were called *Kanji*, meaning "symbols from Han" (a dynasty in China). Until then, Japanese was a language only spoken. The Japanese matched the meaning of characters to words in their own language. In most cases, the original Chinese phonetic reading was also retained as an alternative reading to the Japanese. Thus, a single character has multiple readings, which depend on usage. (This means there are many homonyms, which are distinguished by context.) The basic differences between the two languages meant that a simple borrowing of *kanji* to write down Japanese was not sufficient. (Japanese is a highly inflected language, unlike Chinese.) A second writing system, with fixed phonetic values, was created, known as *Kana*, meaning "assumed names." *Kana* comprises two syllabaries: *Hiragana* and *Katakana*. *Hiragana* was developed from the cursive form of characters while *katakana* are generally based on parts of characters. *Hiragana* is used, like the alphabet, to spell out words, but it is also used in conjunction with *kanji* for inflections. *Katakana*, on the other hand, is used for foreign words, introjections and onomatopoeic words.

PAPER JAM

Designed, or "reproduced," by type foundry and design team
T.26 as an EPS graphic, the warped image above is inspired
by the outcome of mechanical failure caused by a paper jam.
Other graphics within the set, appropriately named Error,
are the consequence of similar machine failures; for example,
a fax machine nearly depleted of its toner or a connection that
has been terminated.

Locale

What is the influence of geography on type design? What influence do nation, culture and history play on the understanding and usage of typography? In this section, the selection of work sets up a series of contrasts between widely disparate locales as well as content and form. We see work from a young Columbian designer applying his type designs onto a snowboard. A German typesetter and designer has rendered an essay about the unification of Germany. Two Japanese designers address the issues of designing home appliances for a new generation of buyers while maintaining roots in traditional aesthetics. And a graphic design magazine publisher discusses layout issues in relation to cultural specificity.

dune buggies, dirt bikes, speed boats, jet-skis, and the like – that each weekend make war on

security guard while incubat fantasies of Aryan vengeanc

THE LAS VEGAS *miracle*, IN OTHER

demonstrates the fanatical persistence of

ronmentally and socially bankrupt system

settlement and it confirms Edward Abb

nightmares about the emergence of an ap

urbanism in the Southwest. Although pos

philosophers (who don't have to live there

in the *Strip*'s "virtuality" or "hyperreality," mos

County is stamped from a monotonously

TYCOON GRAPHICS Page 030

EMIGRE Page 034

TYPO 5

A native of Bogotá, Colombia, Germán Olaya is the young designer of the website www.Typo5.com. Despite an impressive portfolio of work, Olaya's history of creating digital type is not extensive. He is, rather, part of the explosion in type design that has come about since the appearance of software such as Macromedia Fontographer, and with easy user-to-user distribution over the Internet. But only recently has this new generation of designers started to reveal a firm understanding of design principles and typographic rules. Their work now demonstrates a refined sensibility toward type where there was once little awareness of letterforms.

It is becoming clear that type design can actually serve as the kernel for other forms of graphic design—even graphics that are entirely devoid of typography. As Olaya puts it, "Typography by itself is a design—though design by itself isn't necessarily typographic. Typography not only teaches concepts relevant to type or the way to use letters. It also opens the way toward understanding form, balance, and other things that aren't directly related to an alphabet." The lines between graphic design and typography are becoming less distinct; or, more accurately (particularly with the contributions of designers such as David Carson), type and graphics now exist on the same plane. This is true not only of display type and layout; individual letterforms are themselves examples of this phenomenon.

In Olaya's Push 29 "snowboard-design" series (page 023), the graphic forms are generated entirely from typographic layouts. The image incorporates the "S" of Olaya's digital font Fashyon, and is accompanied by photographic compositions. The letterform itself is treated simply as a geometric form. As we see in many examples throughout this book, modularity—the concept of discrete "sets" of information—has had an important effect on typography, as on design in general. The process of composition has a different focus and tension to it, now dealing as it does with individual components. As with type, individual letters, in their own well-wrought forms, have more bearing on the overall "set" (i.e. alphabet). Likewise, graphic elements are component parts of a larger "set" (i.e. image). Olaya says, "Not only does each character look beautiful, but also their multiple combinations will transmit the atmosphere of the original creation." If a font works well, then the whole assembly of type using that font provides new and unforeseen relationships through compositional permutations; that is, words.

Until recently, locale has been a significant influence for this Bogotá-based designer. Street signage and kitsch imagery in the city echo some of the traditional and historic visual tropes of the country of Colombia. Several of Olaya's typefaces and projects are inspired by the surrounding colors and type design. He says that the more casual street-signage styles—of venders selling "empanadas, tamales, and hotdogs"—were the basis for Fashyon, which mixed calligraphic shapes (particularly the "H" and the "Y") with script elements. But Olaya concedes that in recent years his particular locale has become less and less influential on his work, as new media provide him with ever more ubiquitous global access. Ultimately, however, he says, "It depends on how you put it together using all those unique personal and cultural factors to which you are exposed."

COMING SOON

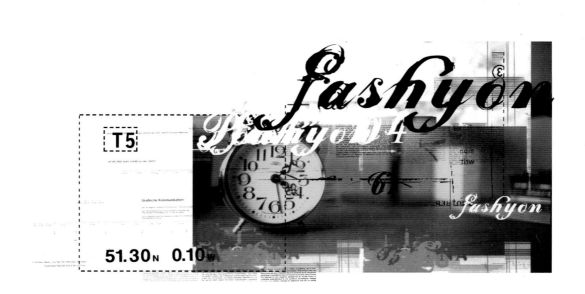

DOC. 2002

Docuverse.de

DOC. 2002

T + 49 6181 87399
F + 49 6181 87399

Docuverse_ in code we trust

www.docuverse.de info@docuverse

SYMPHONIEKONZERT

MOZARTFEST
W A MOZART UND DER FRUHE BEETHOVEN
2003
SYMPHONIEKONZERT
Mozartfest _

VERMÄHLUNG ZWISCHEN TON,
ARCHITEKTUR UND FARBE FAND STATT. DIE TÖNE SCHWEBTEN BEINAHE SICHTBAR ZU
ALLEN TIEPOLO'SCHEN KOSTBARKEITEN HIN UND DIESE SELBST GABEN IHRE LETZTEN
PLASTISCHEN MÖGLICHKEITEN MIT DANK ZURÜCK.– DAS MOZARTFEST WÜRZBURG
WAR GEBOREN'

SELF-PROMOTIONAL GRAPHICS AND POSTERS

Pages 017–019: Several of these graphics grew out of the designer's work for his own website and the need to illustrate his own typefaces. In the process of creating these secondary graphics, the typography became the springboard for new design.

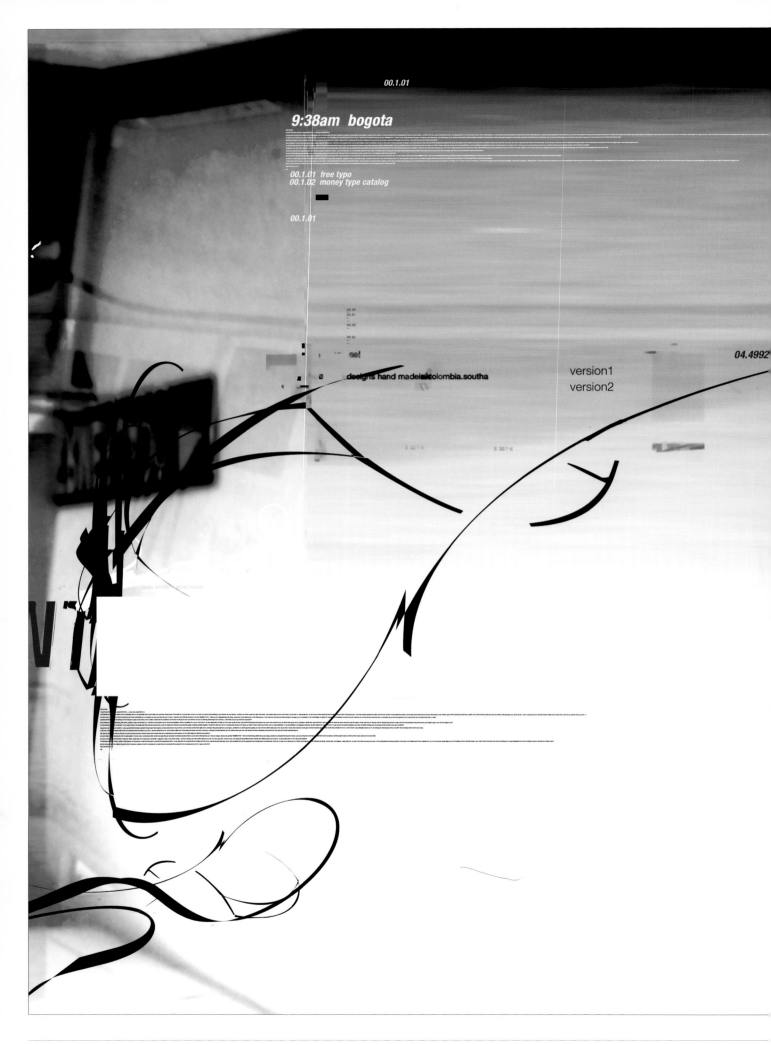

9:38am bogota

00.00

00.01

00.01 a

00.01 b

00.02

00.01 a

00.01

00.01 a

00

00.01 b

00.01 a

00.01 b

DIANA

TOP PAGES

Previous spread: Top page design for Typo 5's website.
Above and opposite: Typeface title pages. *Opposite:* Monson
Snowboard Design. The design utilizes his typography and is
entitled "Push 29."

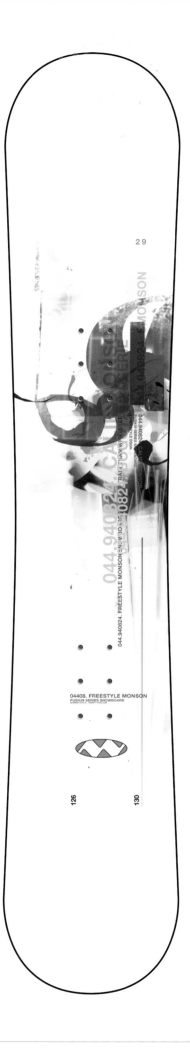

OFFICINA LUDI

In the small village of Grosshansdorf, near Hamburg, Dr. Claus Lorenzen operates his letterpress. He creates hand-printed illustrated books and posters in editions limited to a maximum of 200 impressions. Although all the printing is done on a press, Lorenzen also makes use of digital technologies to create plates from photographic material.

As with William Blake's illuminated manuscripts, the content of Lorenzen's work deals with a culture of thought and history. The pages reproduced here are from Nobel laureate Günter Grass's *Ein Schnäppchen Namens DDR*, a book Lorenzen printed and published in 2000. This collection of excerpts from Grass's essays, interviews, and speeches deals with East Germany's political changeover and the subsequent infiltration of Western culture. He contends that, with unification, the country's gains were outweighed by its damages, and this book is something of an elegy to all that was lost (mostly by the East). Here we see an avalanche of billboards, flyers, and other forms of visual advertising filling the streets of East Germany. At no point do these banners, logos, slogans, and catchphrases blend in with their environment; the clash is as jarring as the social changeover.

Lorenzen explains: "The glittering West, with its colorful advertising, only contrasts with the gray East, with its ruins, dirty factories, and simple shop goods; the two worlds would never "grow together" within a couple of years, as it was initially thought. It was not a partnership between two independent and equal countries. It was the relationship between a winner and a loser." That relationship is paralleled in the production of the book itself: it is printed on fine paper, wrapped in a dust jacket made from a brown-paper shopping bag—an original from the former East Germany. After the country's unification, the East's economy was dominated by the West German mark, symbolized by the mark combined with the flag of the former German Democratic Republic.

Similarly, the typography throughout the volume functions metaphorically for the text. For example, the letters in the word Freude ("joy") on pages 4 and 5 seem animated; and the word Hass ("hate") on page 25 is rendered as a burning flame. The graphic elements that once symbolized the East have now been discarded and are rapidly becoming a memory, as represented by the printing: a barely visible pattern of assembled logos of the former GDR—of businesses, factories, the army, or the Socialist party, for example—is printed in clear ink, a wash that is trampled by oversized letters. The troubled emotions in Lorenzen's bookwork reference East Germany's sudden dissolution. "Everything people in the East had built up during forty years had lost all value within one day. A whole country—and its people—had become 'litter,' an inexpensive commodity available like an old rug at the flea-market (or like the old lead types in the old-fashioned print-shops). The whole former GDR had become a *schnäppchen* (a cheap thing, a bargain)."

Despite the handmade nature of Lorenzen's work, it has a very contemporary feel, not unlike designs created for the computer screen. The bookmaker acknowledges that digital technology does influence his work. But one salient difference is the assertiveness that printed letters have on the page, which cannot be reproduced by electronic media. Bookmakers and book artists are often asked if they fear that their work will be rendered obsolete with the influx of new digital media. But it would seem that, rather than wholly replacing the book, digital media will, in fact, enrich the livelihood of book arts. Those areas that can be ably and wholly fulfilled through electronic media will free up the book arts to delve further into the particulars of handmade crafts produced in limited editions.

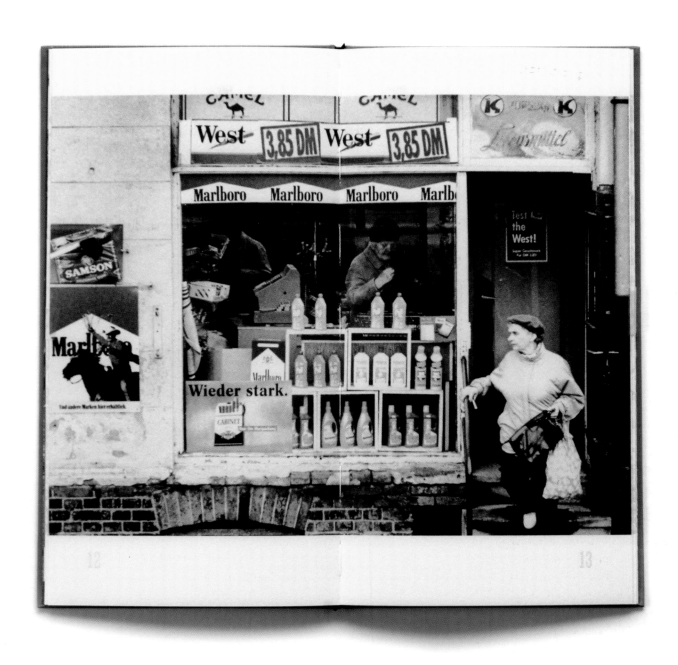

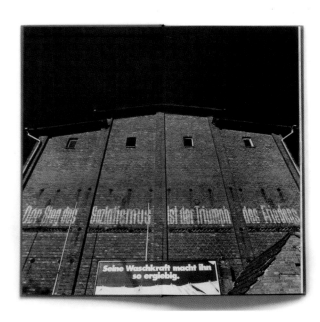

EIN SCHNÄPPCHEN NAMENS DDR

These pages are from a letterpress-printed book. (The photographs were offset printed in duotone.) Like the master printers of former times, the printer, Officina Ludi, is also the publisher. Written by Günter Grass, the book discusses the assimilation of East Germany into the powerful economy of the West. The text is a somber lament for a culture discarded. The picture above is of a shop in a former East German town, the tobacco advertisements standing out in jarring contrast to the otherwise sedate milieu. *Right:* Endpapers.

Locale

UN RECHT RECHT

Welcher Stumpfsinn
hat uns angestiftet,
den Zuwachs von
16 Millionen Deutschen
nach Art der Kleinkrämer
zu verrechnen und dem

RECHT

des Realsozialismus
das hausgemachte

RECHT

des Kapitalismus
draufzusatteln?

14

15

EIN SCHNÄPPCHEN NAMENS DDR

The initial layout of the graphics and text elements was done
on computer, with the plates subsequently output from these
files. Although the printed sheet is generated by hand, most of
the text elements are not moveable. The parts that are moveable
were set by hand at the "Greno" workshop in Noerdlingen.

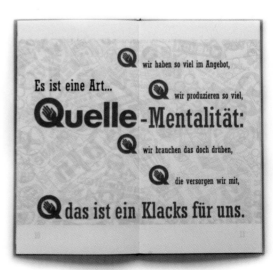

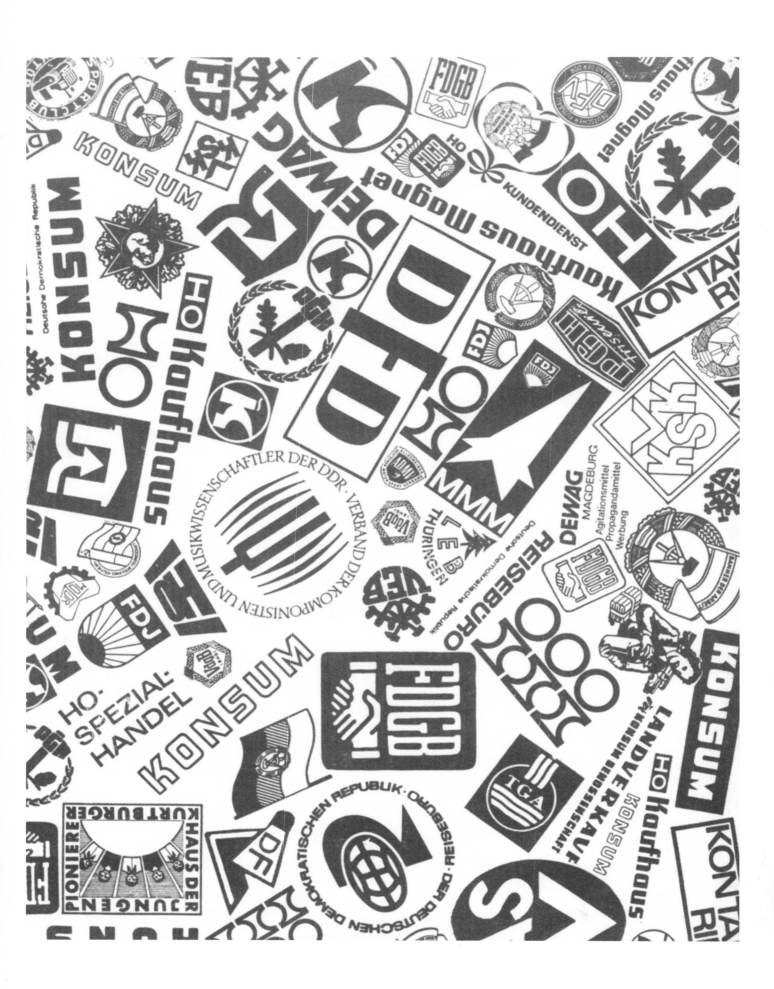

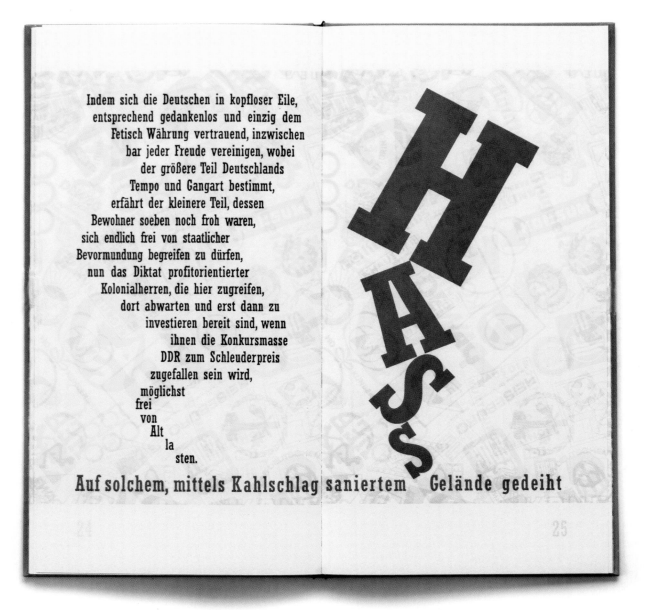

Indem sich die Deutschen in kopfloser Eile,
entsprechend gedankenlos und einzig dem
Fetisch Währung vertrauend, inzwischen
bar jeder Freude vereinigen, wobei
der größere Teil Deutschlands
Tempo und Gangart bestimmt,
erfährt der kleinere Teil, dessen
Bewohner soeben noch froh waren,
sich endlich frei von staatlicher
Bevormundung begreifen zu dürfen,
nun das Diktat profitorientierter
Kolonialherren, die hier zugreifen,
dort abwarten und erst dann zu
investieren bereit sind, wenn
ihnen die Konkursmasse
DDR zum Schleuderpreis
zugefallen sein wird,
möglichst
frei
von
Alt
la
sten.

Auf solchem, mittels Kahlschlag saniertem Gelände gedeiht

RELICS OF LOST CULTURE

Various logos that were commonly seen in East Germany
quickly vanished from sight after unification with the West.
Lorenzen assembled these relics of a lost culture to create the
base pattern used as the background of this book. After the first
impression of the plate was made, the pattern was rotated 90
degrees and printed once again, rendering an overlap.

TYCOON GRAPHICS

Consumers and users are rarely aware of the vast extent to which product design avails itself of language. In an effort to make machines and tools ergonomic and easy to use without supplementary instruction, product designs tend to be tailored to facilitate communication with their users. With certain products (such as coffeepots and other household appliances) there is such established familiarity with their operation that little textual instruction is needed; gauges and meters are enough for most users.

We are so familiar with the specific shape of a coffeepot that its design cannot confound its usage (in the same way, we almost always recognize letterforms, no matter how stylized their design). The icons for various switches on familiar machinery and appliances have undergone a process of simplification over the years that reflects this presumed recognition. As technology becomes more pervasive, we require less data with which to identify the functions of a machine. And with extended use, such icons and markings become virtually superfluous.

With this in mind, designers Yuichi Miyashi and Naoyuki Suzuki of Tycoon Graphics art-directed a line of household appliances called Ateheca. The icons are small and simplified. The buttons themselves blend into the overall interface of the product, drawing little attention to themselves (a marked difference from those on typical Japanese appliances). The logo language of these buttons is as streamlined as the product itself, serving the overall design intention: to create a seamless connection between lifestyle and product. At the same time, it provides a response to traditional Japanese aesthetics, including familiar motifs, such as the nested box.

Tycoon Graphics' work on a line of men's suits called Motion Element began with brand identity, resulting in the creation of a logotype and a brand symbol. This symbol (page 033) then recurred on the clothing line's labels, boxes, and point-of-sale material for the shop interiors. Type design, in this sense, serves as the starting point for derivative graphics that all function along a common visual theme set up by the logotype and logo itself.

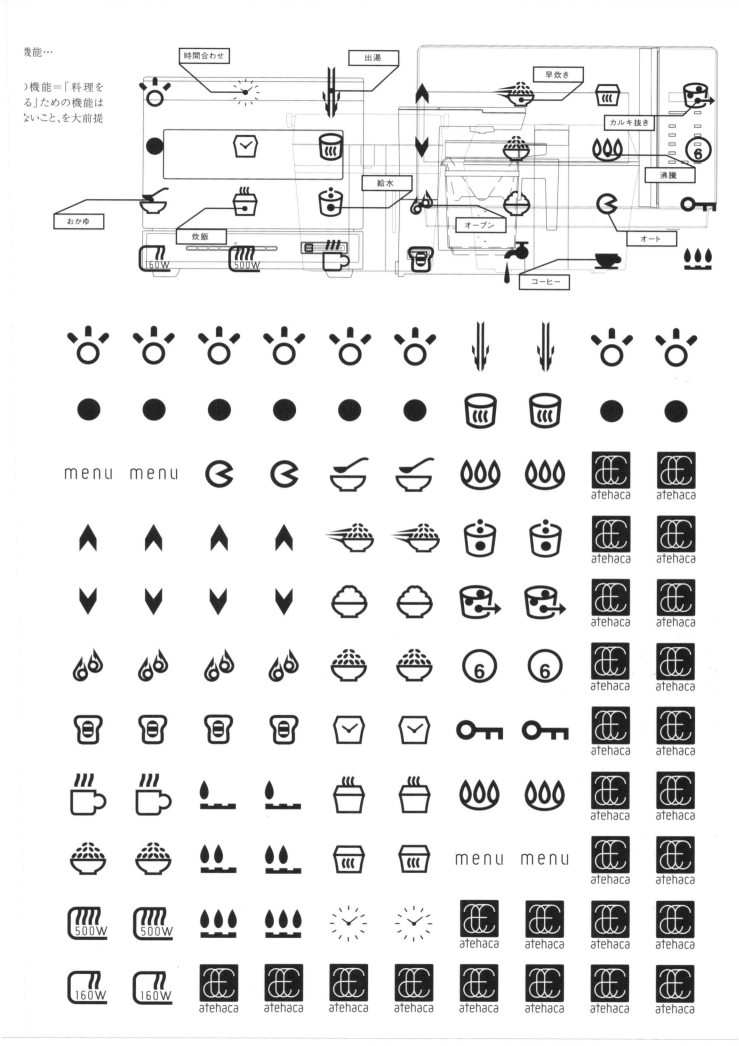

ATEHACA ICONS

Previous Page: Tycoon Graphics created these icons as part of the user-interface for the Atehaca range of kitchen appliances. The product design is a confluence of traditional Japanese aesthetics with streamlined convenience and modernity. This approach is reflected in the icons themselves, which draw from traditional Japanese lettering and graphics. The icon, they say, has an extended history in Japan, the *inkan* (stamp or seal) being an irrefutable example.

LOGO MARKS

Left: Similar in function to the personal signature, the red graphics here are typical examples of seals that are used by craftsman, artists, and company executives. The names of the principal designers for Atehaca—Shuwa Tei (*above*) and Tycoon Graphics (*below*)—appear in black ink. The red graphics are the *inkan* versions of their respective names. As a rule, the *inkan* is printed in red ink. Both the brush-pen calligraphy and the *inkan* fully utilize the space to render a balanced whole. Usually, the outcome is highly stylized, placing precedence on form over legibility.

ATEHACA LOGO

Below: The resultant logo for the Atehaca line of products derives its general design concept from the traditional Japanese *inkan*. Apart from the amalgamated letter formation, the reversed-out white type on a colored background also borrows from the *inkan*, which was traditionally formed by a pattern carved into a block of stone or wood.

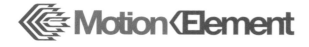

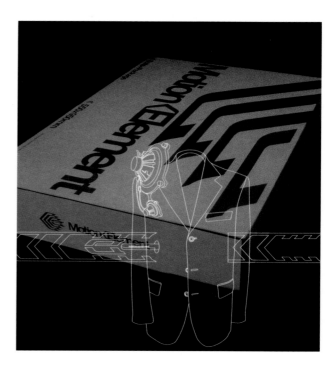

MOTION ELEMENT

With a similar ethos to that of Atehaca, this brand of suitware gives a modern twist to a traditional garment: features include loop holes through which earphones can be strung and slim pockets for mobile phones. The primary red graphic is the identifying mark for the brand, and serves as the motif for derivative graphics used in the packaging and presentation.

EMIGRE

Launched in 1984 as a periodical devoted to cross-cultural concerns, *Emigre* has come to be known as a leading magazine devoted to typography and graphic design, as well as a type foundry by the same name. The venture was initiated by Rudy VanderLans (a Dutch émigré to California), together with Slovakian-born typographer Zuzana Licko. Publisher VanderLans does everything at the magazine, from design to editing, writing, sales, and promotion. This autonomy gives his team great freedom to pursue their own interests with the magazine (and creates an intimate bond between VanderLans and his journal). But total control is also something of a burden, blurring the lines between life and livelihood for VanderLans. That said, the magazine exhibits a great degree of personal character, in terms of both content and design.

VanderLans feels that much of today's "globalized" design sensibility suffers from a lack of cultural connection. He says, "I see a real decrease in culturally specific work. I see so much graphic design being produced today that seems created independent of its surroundings. In other words, it has become ever more difficult to guess where any particular piece of design comes from. In a sense, it's like an international style dream-come-true. But I think it's an impoverishment of culture. I like it when someone wears their immediate environment on their sleeve. Today, there are so many "globalization" forces at work to make everything look the same, that I think it has become the responsibility of everyone, including designers, to point out and maintain our respective cultural features. Designers can do this through their work, by looking for inspiration from sources close to them."

The notion of making a magazine about people and their ideas comes as a welcome contrast to the concept of "seamless discourse"—that breed of anxious writing and theorizing that tries to conceal its own subjectivity in order to maintain an illusion of authority. In this sense, *Emigre* takes a refreshingly humanistic approach. What's said in the journal is said by a person—the ideas/words don't exist separately from the mind/heart that conceived them. From a critical standpoint, this is the crux of the magazine. It is paralleled in *Emigre*'s typography itself, which is very charged with character. VanderLans says, "Typography and type design are ways to express your culture, your creativity, and your intelligence. When you become seriously involved in these disciplines, you soon become aware of this huge, rich legacy you are now a part of. Design is a cultural force. Everything we do as graphic designers impacts others on a variety of levels." In its first issues, *Emigre* was about the exposure to various cultures; the magazine eventually became recognized particularly for its original layouts and unique type treatments. Soon, graphic design and typography became *Emigre*'s main focus.

After several years of groundbreaking work, VanderLans discovered that his audience came to expect him to dispense with convention: rule-breaking itself became a rule. "Obviously, convention-breaking should not be an end in itself," he says. "The idea of questioning rules and conventions is a good thing, because there is always room for improvement. But, more often then not, when you break the rules, you quickly realize the established rules are not so bad. I think the trick is that you should know the rules before you try to break them."

EMIGRE

Cover design for the Winter 1995 issue of *Emigre*; design and
layout by Rudy VanderLans.

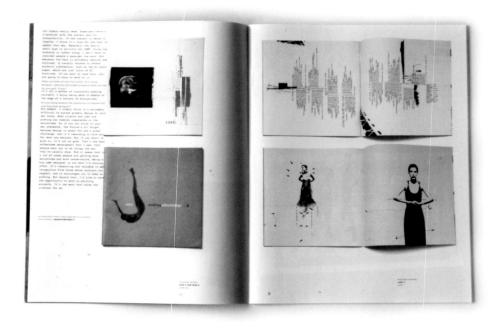

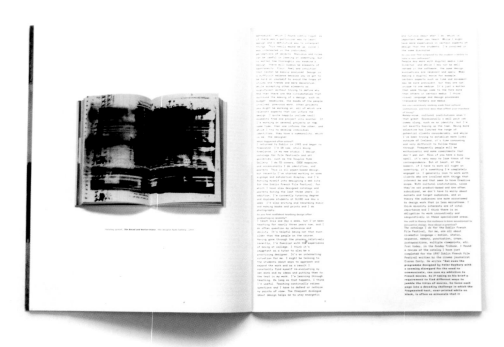

certain aspects such as time and movement
may be more prevalent, but they are not
unique to one medium. It's just a matter
that some things come to the fore more
than others in certain media. I think
visual language and design processes
transcend formats and media.

*Are you consciously seeking work from cultural
institutions, and how does that affect your standard
of living?*
Money-wise, cultural institutions aren't
that great. Occasionally a well paid job
comes along, such as an identity, but I'm
not exactly buying up the town. Being more
selective has limited the range of
potential clients considerably, and while
I've been trying to establish more links
outside of Ireland, it's time consuming
and very difficult to follow these
through. Frequently people will be
enthusiastic and make commitments that
don't pan out. Also if you have a busy
spell, it's very easy to lose track of the

EMIGRE, NO. 45

The article that is reproduced here is an interview with book
artist Peter Maybury. The artist's work is identifiable for his
limited use of color, his reliance on text and blocks of black,
as either blotches of color or photographs. VanderLans' design
and layout of these pages follows a similar aesthetic, making
ample use of white space and cleanly organized type as
counterpoints to the experimental nature of the work featured.

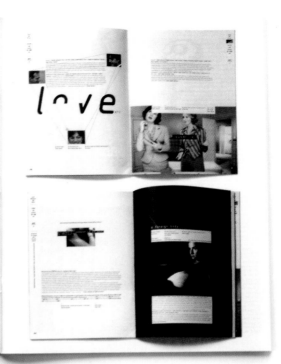

Lili Dujourie

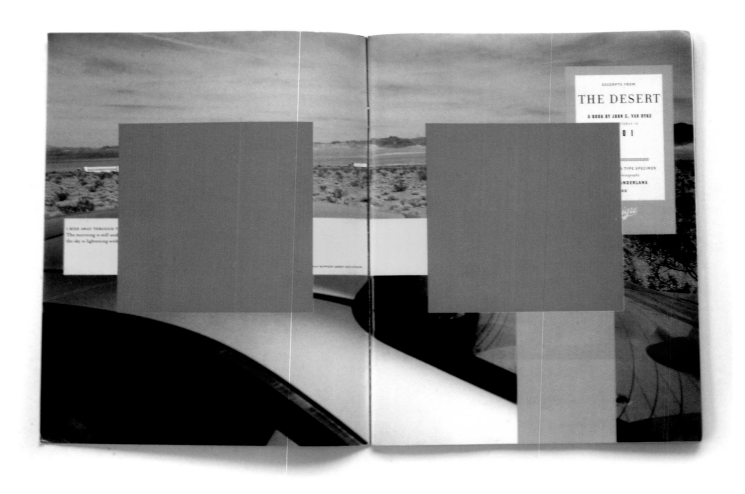

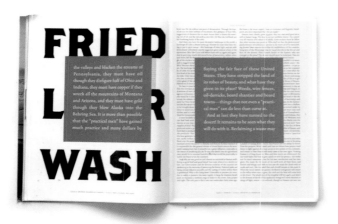

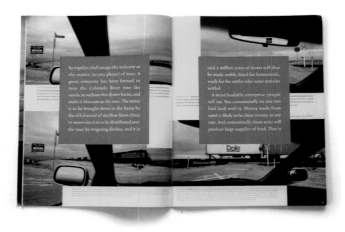

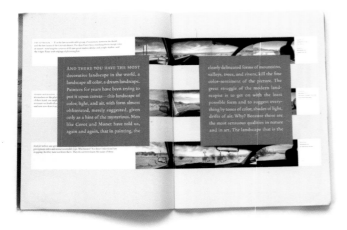

EMIGRE, No. 55

Spreads from a leisure-time issue of the magazine featuring excerpts of a book by John C. van Dyke. The book is itself an Emigre publication and incorporates photography and type specimens by Rudy VanderLans. Without exception, red squares are centered on each page, serving as the tableaux for the reading copy.

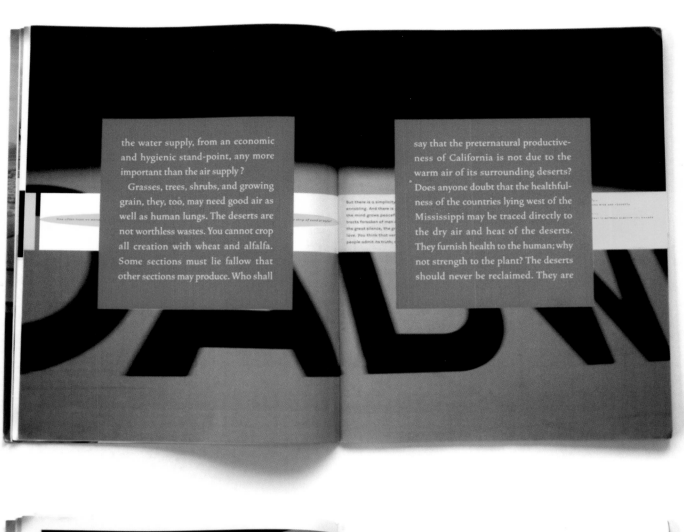

the water supply, from an economic and hygienic stand-point, any more important than the air supply?

Grasses, trees, shrubs, and growing grain, they, too, may need good air as well as human lungs. The deserts are not worthless wastes. You cannot crop all creation with wheat and alfalfa. Some sections must lie fallow that other sections may produce. Who shall

say that the preternatural productiveness of California is not due to the warm air of its surrounding deserts? Does anyone doubt that the healthfulness of the countries lying west of the Mississippi may be traced directly to the dry air and heat of the deserts. They furnish health to the human; why not strength to the plant? The deserts should never be reclaimed. They are

commendable, too, even if those for whom it is produced waste a good half of what they already possess. And yet the food that is produced there may prove expensive to people other than the producers. This old sea-bed is, for its area, probably the greatest dry-heat generator in the world because of its depression and its barren, sandy surface. It is a furnace that whirls heat up

and out of the Bowl, over the peaks of the Coast Range and into Southern California, and eastward across the plains to Arizona and Sonora. In what measure it is responsible for the general climate of those States cannot be accurately summarized; but it certainly has a great influence, especially in the matter of producing dry air. To turn this desert into an agricultural tract

"There are features about advertising — some kinds of advertising — that are emphatically not points in a gentleman's game. The major part of the activity is honorable merchandising, without taint. But there are projects that undertake to exploit the meaner side of the human animal — that make their appeal to social snobbishness, shame, fear, envy, greed. The advertising leverage that these campaigns use is a kind of leverage that no person with a rudimentary sense of social values is willing to help apply..."

W.A. DWIGGINS, *Layout in Advertising* (1928)

WE NEED THINGS CONSUMED, BURNED UP, WORN OUT, REPLACED, AND DISCARDED AT AN EVER INCREASING RATE.

VICTOR LEBOW QUOTED IN *Saving Advertising, Page 4*

IF EVERYONE CONSUMED THE WAY AMERICANS DO, WE WOULD NEED FOUR MORE EARTHS TO SUPPORT IT.

FROM *Saving Advertising* BY JELLY HELM, *Page 4*

EMIGRE, NO. 53

The theme for this issue of the magazine is advertising. Photographic images have been enlarged and reproduced to show the dots of the four-color printing. Similarly, one-word questions are blown up and overlaid onto the images. The layout itself is sectioned, compartmentalizing images, catch copy, and body copy into their respective sections.

Illustration

At what point does a letterform become a simple graphic element? How does type function like drawing and vice versa? Can images function as legible graphics themselves, on a par with type? The work assembled for this section deals with illustration in a variety of media and in various formats. The first case study includes designs for Japanese sake bottles that make substantial use of traditional Japanese calligraphy in their branding. This contrasts the logotype design for a selection of German music posters and product designs. An American designer and typographer shares pages from his scrapbooks, which are the inspiration for his type designs. Also included is the work of a Japanese design duo who conflate (and confound) Chinese characters and the alphabet while using graphic design as a means of reading.

Biosys® Probe Unit
バイオニック・システムズ
A 0759

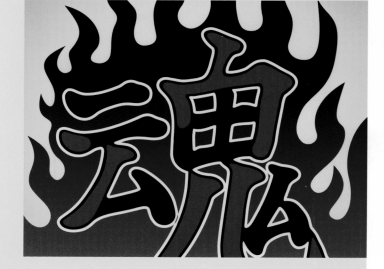

BIONIC SYSTEMS Page 074

DAINIPPON TYPE ORGANIZATION Page 084

GRAPH

As with most writing systems with pre-industrial roots, *kanji* (Chinese characters of the Japanese syllabary) did not originally comprise a fixed, or even consistent, set of pictographs. That is, none of the hand-drawn (or carved) characters precisely resembled some "perfect" form. In the evolution of *kanji*, each time a particular character was written or copied, it often became another version of the same character, containing what the scribe perceived to be the intrinsic properties of that character. So what was kept, discarded, emphasized, or deformed in each generation of copying and usage eventually determined the final, fixed form of the character. Up until the establishment of that fixed form, each character had its own unique and distinct value, however minute the variation from its cognates.

An understanding of the individual variability of characters is fundamental to the typography and design of Graph's Issay Kitagawa. As seen in the examples of display type here, individual letters within the same line of type are distinct from one another. The design of the font is as important to the overall atmosphere of Kitagawa's works as a discrete set of letters or characters. It is interesting to recall that when Kitagawa's type designs for book jackets and other media were first seen, there was quite a bit of negative response to his rejection of rigid type conventions: he had broken the unspoken rule that all type must conform and be consistent. Kitagawa's process with type is parallel to Graph's approach to printed matter in general. Using various printing techniques, they control the extent to which each item of the mass-produced whole is identical to another; all printed items have small degrees of variation.

The balance between the simple strokes of *kana* (the phonetic letters of the Japanese syllabary) and the multiple strokes and complex structures of *kanji* has always been of particular concern for someone attempting to set type in Japanese. Visually, *kana* and *kanji* have very different visual weights. So, setting type at the one consistent point size, for example, can make the overall composition look rather awkward.

Graph's treatment of the logo for Fukugura is an example that makes good use of this dichotomy. (Fukugura is a restaurant that serves Japanese food and sake in a converted warehouse that is more than a century old.) The curlicue character *fu* and the blocky shape of *kura* not only convey individual meanings but together create a significant image (page 046). The *fu* character (its sound is reminiscent of the wind) takes the shape of a cloud passing over the *kura* (representing a warehouse) below. The interior structure of the lower character, drawn with thick, descending lines, alludes to the metal-clad wooden door of old warehouses. The top radical (meaning "grass") cuts across the horizontal length of the character like a guard-post. Thus, the top image synchronizes the somewhat ephemeral quality of Fukugura with the readily identifiable character below.

In the ongoing move from handcrafting to the machine-produced product, there are of course myriad changes, some bad and some good. Graph's designs are created with a sensitivity to these changes and permutations, and they manage to maintain an extraordinary aesthetic balance between the two modes of production.

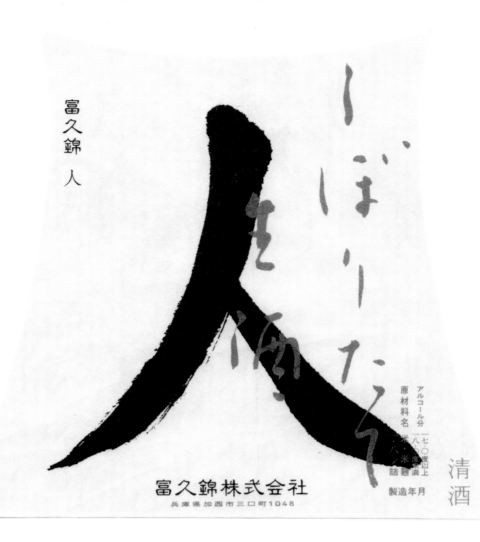

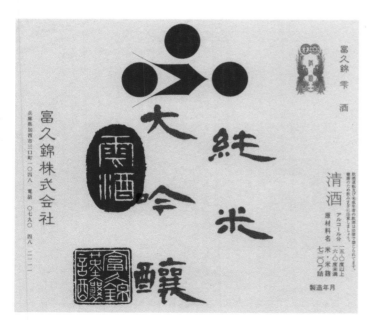

DISTINCT CHARACTERS

Top and above: Sake bottle labels. The representative alcohol of Japan, each variety of Sake has its own distinct character. Not unlike its grape counterpart, this rice-derivative alcohol inspires an awesome variety of designs for its labels, many of which are produced for micro-brews. *Right:* A calendar with hand-drawn numbers based on primitive Japanese character forms.

Graph　　045

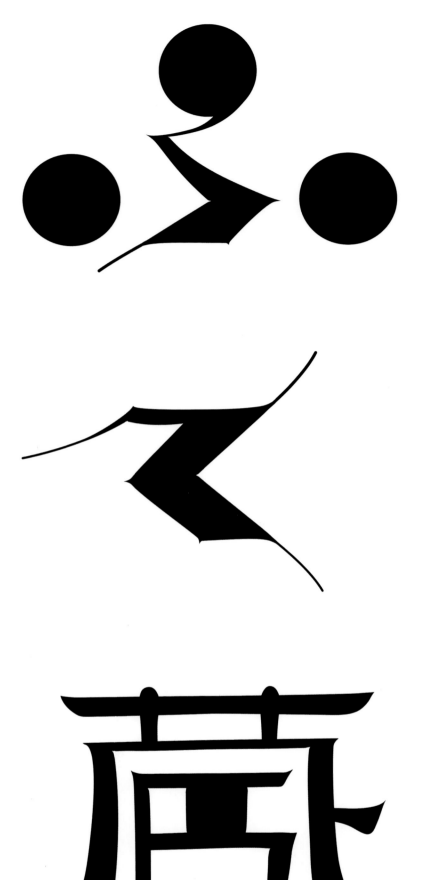

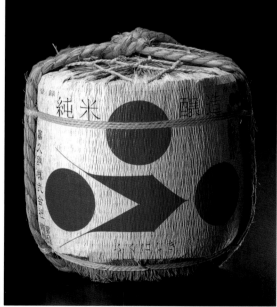

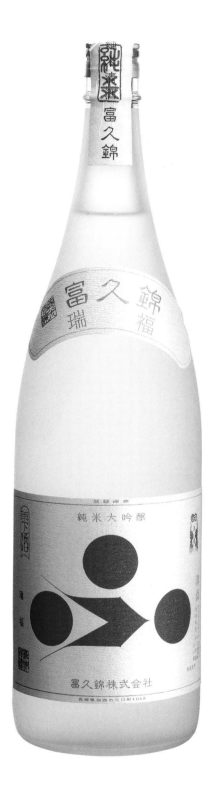

FUKUGURA

Opposite: Logo for the Sake producer Fukugura. The logo itself
is the standard form fukekura ふヶ蔵, each element of which
represents the three different writing systems that comprise
written Japanese. *This page, top:* a *hashioki* (chopstick rest).

Graph 047

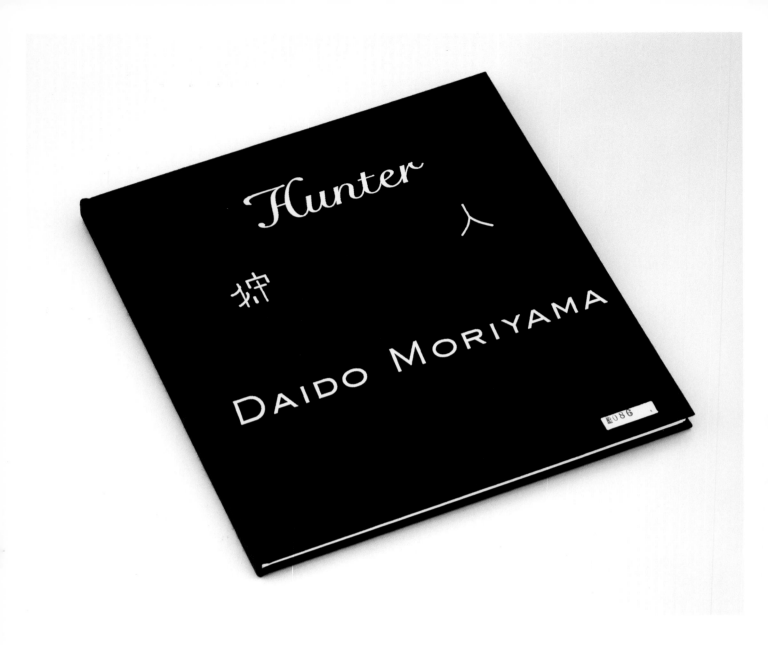

memento mori

HUNTER

Above: Cover design for photographer Daido Moriyama's monograph, entitled *Hunter*. The hand-drawn characters are set so far from one another that they can alternatively be read as individual characters. The second character 人 is isolated, like a hunter in the glen, and the first character (a pictograph) is distorted from its standard form 狩 for emphasis. The left half of the character represents "dog," which lends the meaning of being attentive and protective, while the the right side means "to protect." Thus, "a dog protects its master." Hence the distance between the characters reverses the sense of connection between the hunter and his companion, to emphasize a strained relationship of isolation.

CUSTOM FONTS

Left, top: Corporate logo for the Takaishi Gallery, Japan (TiG).
Center: Hand-drawn lettering for a Shiseido advertisement.
Bottom: Momento Mori was a custom-made font, created for a commemorative publication for a home built by the Mori family.

Graph

049

GRAPHIC ADAPTATION

Top: A children's book about fathers was given this title logo using the two *hiragana* ちち. *Middle*: Title logo for the publication *Fukei*, written in Japanese *hiragana*. *Bottom*: Advertising graphic for Suntory's Shochu beverage. The graphic is an adaptation of the Chinese characters 辛口, which mean "dry taste."

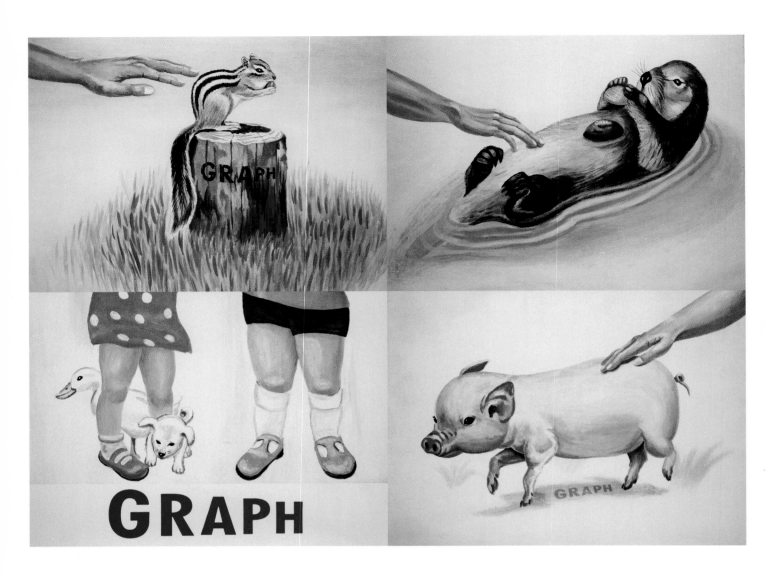

DESIGN × PRINTING =GRAPH

Self-promotional Posters

With illustrations by Mar Sekiguki, Graph produced a series of self-promotional posters that convey the company's "touchy-feely" approach. *Opposite*: The Japanese text translates "Children are born in a darkened room." The gradual progression to a completely darkened rabbit hutch reveals "Graph" glowing in red (*below*). As with the animal-theme drawings, the use of illustration creates a strong contrast to the typography, which is largely devoid of any presence of the artist's hand, and in its practical need to communicate, lends no mystery of its own. The curious nature of these posters gives them their potency.

↓こどもを うむ へやは くらく して やります。

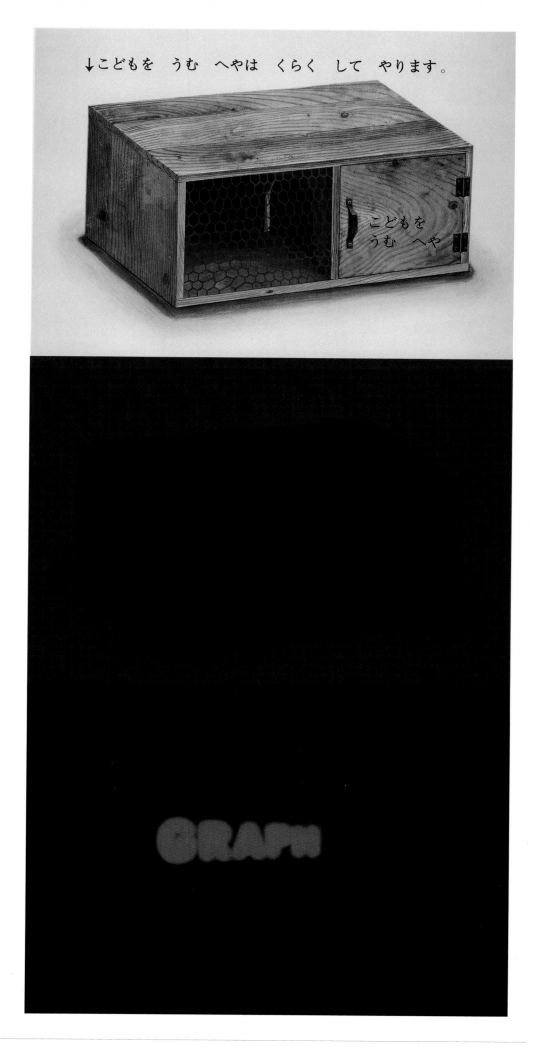

こどもを
うむ へや

Graph 051

T.26

T.26 is the type foundry arm of an organization that
covers music production, package design and graphic
design. Based in Chicago, T.26 also sells fonts by
designers from several countries. Founder and chief
designer Carlos Segura is therefore involved with
numerous aspects of design, all of which inform
and influence one another. Though Segura is actively
engaged in relatively straightforward typography
and font design, the examples of his work shown
here represent a different interpretation of the idea
of a "font."

Error and Chunk are two sets of EPS illustrations. Error
(as implied by the name) is a set of graphics derived from
error messages of various technological machines, such as
photocopiers and fax machines. Chunk is a set of images
that appear to have been photocopied a number of times,
and are now several generations away from the originals
from which they derive. Each image is a monochrome,
outline drawing; the details have lost their sharpness, and
subtle resolution is replaced with high contrast. Oddly
enough, these illustrations have their roots in typography.

Like other fonts, these are available for retail sale,
but—rarely the case with other fonts—users are free to
manipulate the graphics (as T.26's disclaimer states).
Segura explains that while he was working with
typography, he began to think in terms of sets of
graphics. An alphabet is one complete set; similarly,
his illustrations form a discrete set. The notion that an
alphabet is merely a set of graphics comes as something
of a surprise; equally novel is the idea of graphics as a
set, in a sense equalizing the value of the illustrations.
As in the alphabet, there is no central image, and no
representative lead graphic; there is only variation in
frequency. And understanding the graphic sets in terms
of frequency gives us alternative criteria (function and
usability, for example) with which to judge their value.
Certain graphics, such as Book Edge, would seem to be
of little use compared with Fax Bleed or Roller, which
have a lot of clearly positive visual data to be exploited.
Other graphics, such as Roid, border on the abstract in
their near lack of any visual data at all. But all of these
graphics—even the most extreme of them—fall within the
superstructure of the alphabet-set.

Previous page: Dingbat typeface designed by Von Glitschka for T.26. The composition of each dingbat is square, in sharp contrast to Stalker (pages 056–057). Each dingbat is created on a fine grid that makes up its bitmap.

*** ERROR TX REPORT ***

i repeated this page by accidenbt.

Error

Designed by Carlos Segura, this is an EPS set of graphics
(see also Chunk, pages 058–059), inspired by the fax. Though
there is no indication of a fax machine, the familiarity of these
warped images is enough to visually allude to their origin.
Their assembly implies the connection of the otherwise
unrelated and fragmented graphics. In this sense, the limited
repertoire of communiqués making their way out of the fax
functions like a metonym.

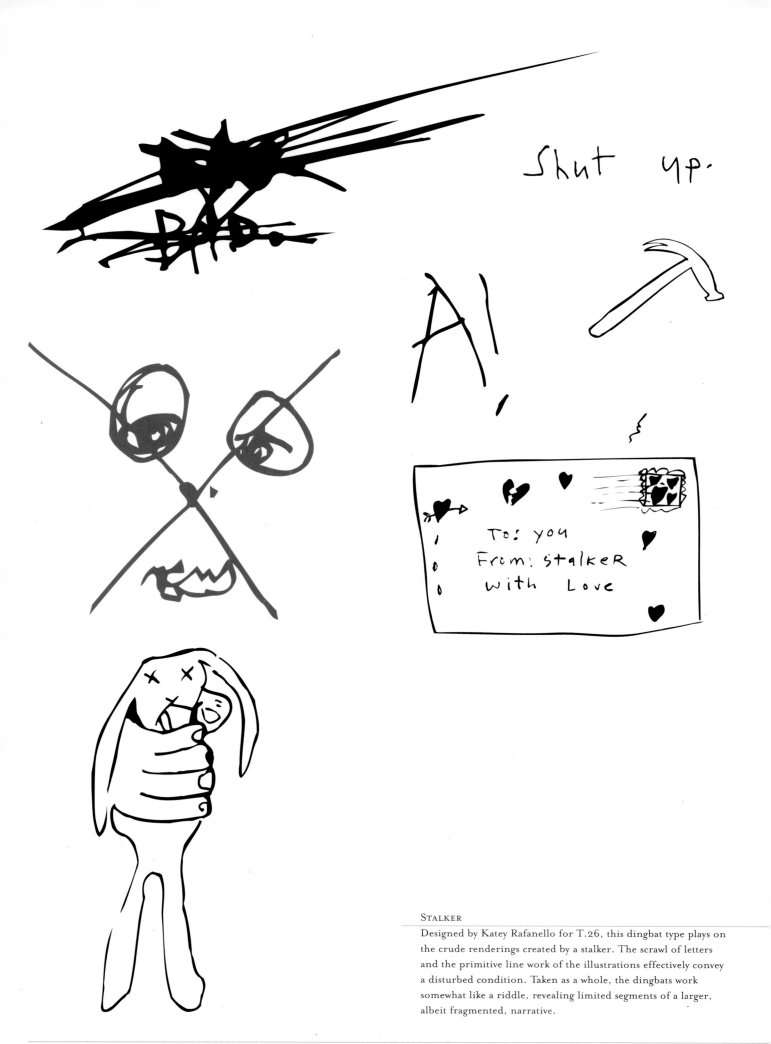

STALKER

Designed by Katey Rafanello for T.26, this dingbat type plays on the crude renderings created by a stalker. The scrawl of letters and the primitive line work of the illustrations effectively convey a disturbed condition. Taken as a whole, the dingbats work somewhat like a riddle, revealing limited segments of a larger, albeit fragmented, narrative.

S t a L K e R

DON'T DO it.

stop.

eat you.

BOO

BOO

O.....

Spirolina

have a nice day.
~~Fuck you.~~

T

i'll help you

Leaving?.

Busted pen

no.

?

CHUNK

Quite unlike a typeface of a dingbat, Chunk is an EPS set of graphics. Like Error (page 054), this set comprises artwork that can be manipulated by the user. The primary sources for the images range from a college student's identification card (*opposite, top right*), the print of the designer Carlos Segura's palm (*far right*), or his own face (*above*).

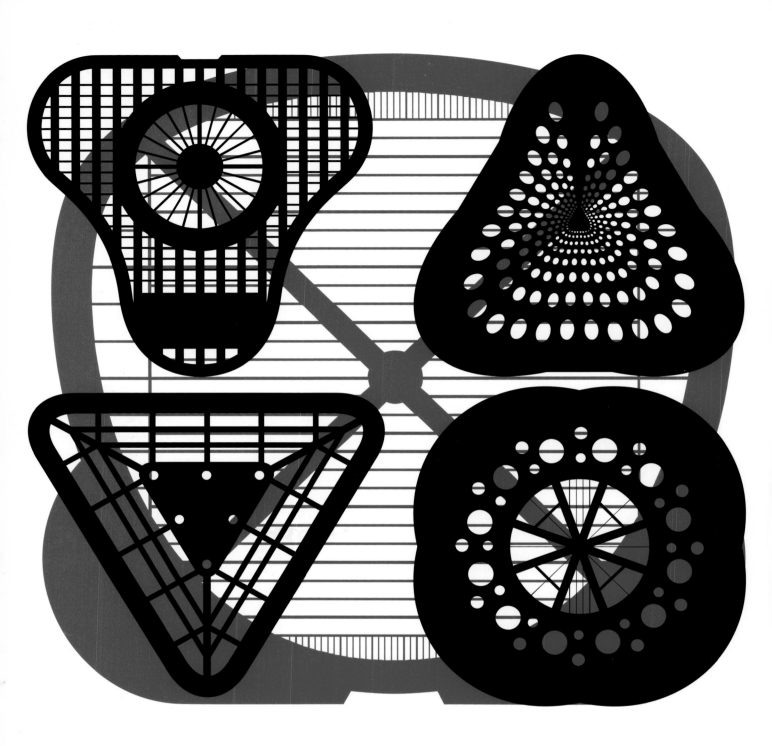

pod™

PEEPOD

Dingbats typeface designed by Carlos Segura of T.26. As implied by the name, the grooves of the individual dingbats, when strung together, neatly fit into one another, much like peas in a pod. The typeface is available in one weight.

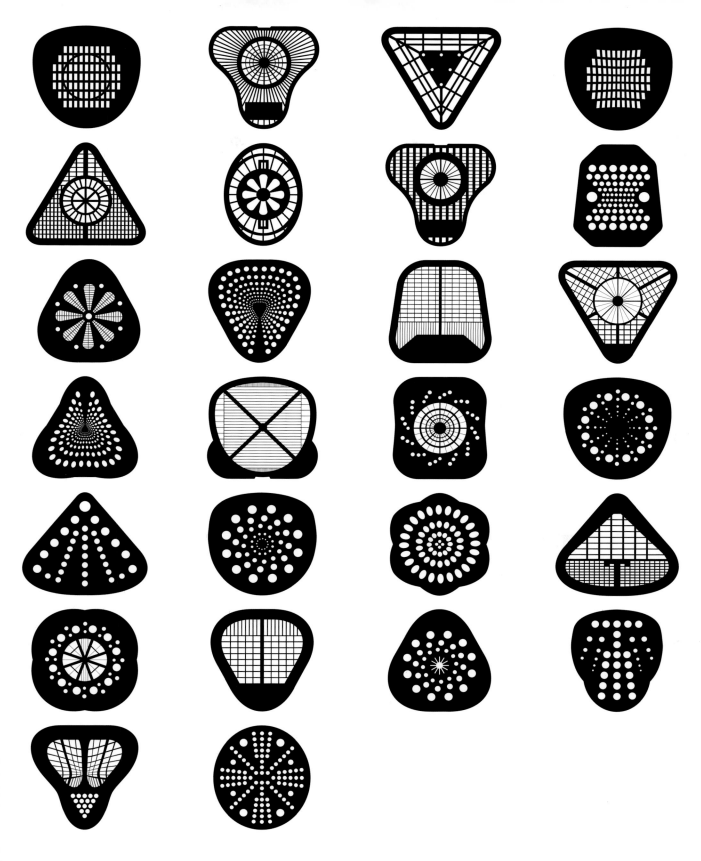

TEST PILOT COLLECTIVE

The grid of images on pages 066–073 was taken from the scrapbook of type designer Joe Kral of Test Pilot Collective, based in San Francisco. The collection of printed-matter detritus is reminiscent of artist Gerhard Richter's *Atlas*, a massive work covering the entire expanse of Richter's life in sections of images. Similarly, Kral's collection of scraps is a sort of diary of his daily life: plane tickets, movie tickets, coffee cups, flyers, drawings, notes.

Kral's creative work is a series of decisions and selections. Choosing an item for his scrapbook is, for Kral, a creative process—the completion of a loose idea that existed in the typographer's mind, actualized in the found object itself. Looking over an extended section of pages from the scrapbook, one discovers a unified aesthetic. What may seem haphazard at first is actually a careful process, for which it is crucial to be ready at all times to receive objects as they present themselves. Kral, in going about his daily business, is exposed to limitless material to choose from. And, of course, the typography that is generated from this procedure carries with it the entire "history" of the found objects.

But this is just phase one of Test Pilot Collective's creative operation. Once the resources have been assembled (like a collection of raw data), the design can be put in place. Actual fonts and graphic elements can be created, all of which derive (loosely or otherwise) from the compendium of stray graphics Kral has been amassing over the years. The notion of repetition and continuity pervades Test Pilot's design aesthetic. The top page of their website (www.testpilotcollective.com) has been updated daily for the past few years. Maintaining the flow of creative energy is central to Test Pilot Collective's work, and requires a daily engagement with their process.

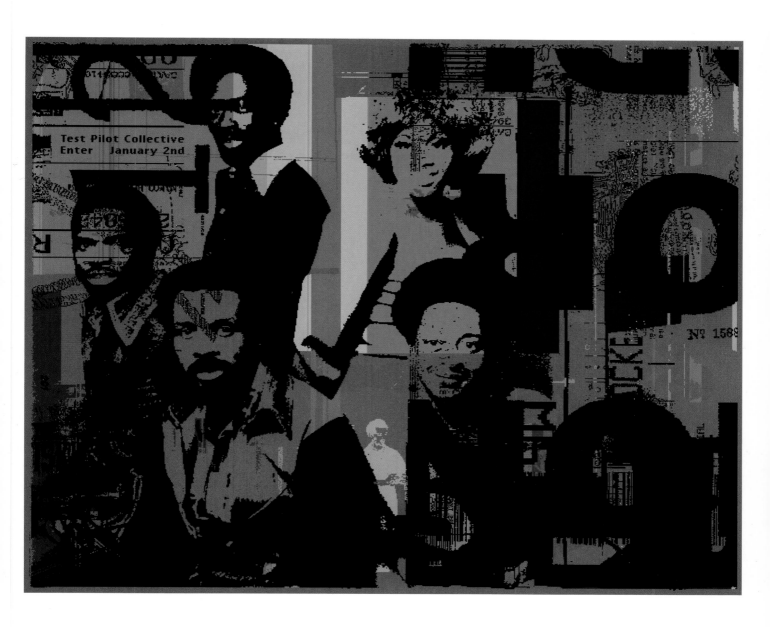

TOP PAGES

A top page from the Test Pilot Collection website:
www.testpilotcollective.com. Every day, a new design for the top
page is created. The steady flow of images, many of which are
derivative graphics of their type designs, draws on a wealth of
sources, mostly found objects. The two illustrations here
incorporate layered images, creating unlikely combinations,
changing context and, thereby, changing meaning.

TEST PILOT COLLECTIVE
IN A WORLD OF COMPROMISE, WE DON'T.

ISSUE: NOVEMBER/DECEMBER 2000 VOL.3 NO.4
SIZE: FULL PAGE W/BLEED 8.375" X 10.875"

USER-FRIENDLY.

TPC ADVERT 05

OCRJ
AaBbCcDdEeFfGg
HhIiJjKkLlMmNn
OoPpQqRrSsTtUu
VvWwXxYyZz1234

OCRK
AaBbCcDdEeFfGg
HhIiJjKkLlMmNn
OoPpQqRrSsTtUu
VvWwXxYyZz1234

TRISECT
aabbccddeeffgg
hhiijjkkllmmnn
ooppqqrrssttuu
vvwwxxyyzz1234

UNISECT
AaBbCcDdEeFfGg
HhIiJjKkLlMmNn
OoPpQqRrSsTtUu
VvWwXxYyZz1234

testpilotcollective.com

TEST PILOT COLLECTIVE: A TYPE AND DESIGN STUDIO
SAN FRANCISCO, CA 94117 USA

ARTBYTE: THE MAGAZINE OF DIGITAL CULTURE.
NEW YORK, NY 10021 USA

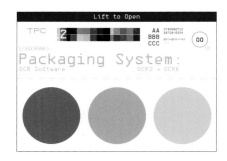

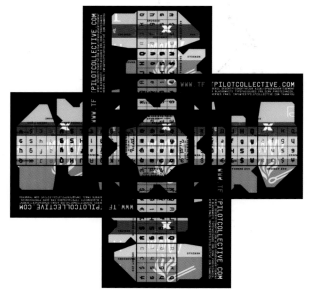

POSTERS

Above: An example of how Test Pilot Collective designer Joe Kral initiates the process of creating a typeface. In many instances, the usage of lettering for signage can also be the basis for a TPC typeface. *Top:* Top page of the Test Pilot Collective website. *Opposite:* Poster design for *Artbyte* magazine.

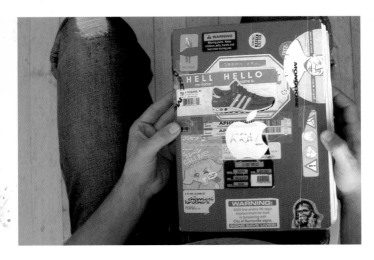
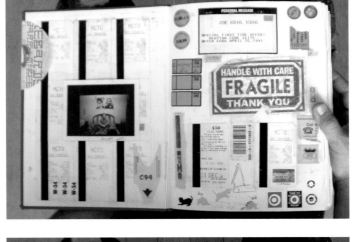

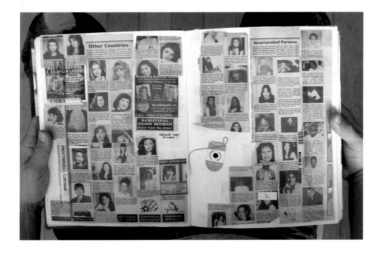

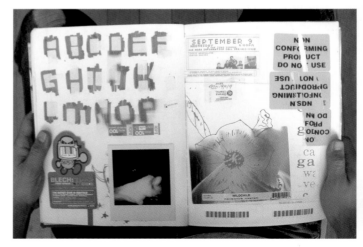

RED SCRAPBOOK

Pages 066–073: Pages from Kral's "Red Scrapbook." The designer assembles bits and pieces from almost anything that comes his way: air freight receipts, magazines, product labels, stamps, and cigarette boxes, for example. The designer then develops typographic reactions to these found objects.

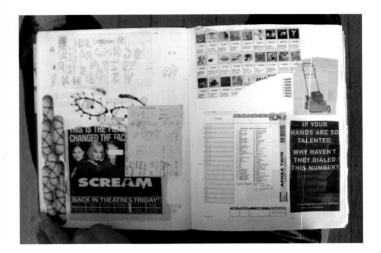

The typeface Doubleoseven (*opposite*) was derived from the mesh of scrap images assembled by Test Pilot Collective designer Joe Kral. The collection was dubbed "The Red Scrapbook".

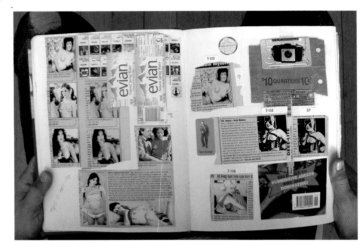

Pyrotechnics (*opposite*) is a combination typeface and dingbat set, which were inspired by the warning label found and pasted into the designer's scrapbook (*left*).

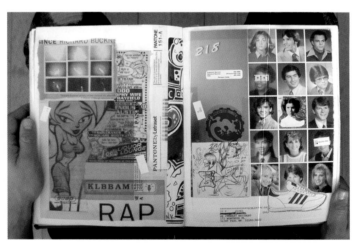

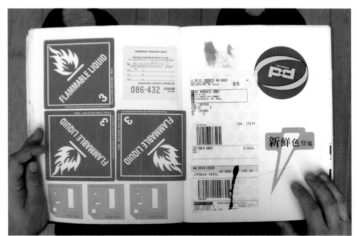

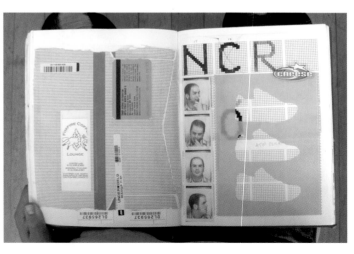

The initial design for the typeface Filament (*opposite*) was based on a "found" lettering sample (*left*). It is but one specimen of a vast array of similarly fragmented pieces of printed matter assembled into the designer's scrapbook. These elements then serves as a trove of ideas for the design of new typography.

BIONIC SYSTEMS

The design duo Malte Haust and Doris Fürst from Düsseldorf collaborate under the name Bionic Systems. As their name implies, there is a keen affiliation on a thematic level between natural and mechanical functions in their work. Living with technology gets taken one step further, where man and machine begin to exist within the same form, as brought to life by the cyborg. Featuring prominently in their website design and a recurring motif within their design work in general, the cyborg summarizes much of their aesthetic. Their work with graphic design ranges from website design, printed matter, to logotype and logo design, and typography. Among several of their fonts, the cyborg spirit shines through, putting life into technology.

One example, as illustrated here, is Doris Orange. The shape of the fruit, from which it also takes its name, was the basis for the typeface. The bulbous shape and the weight of the letters are reminiscent of an orange, in particular its rind. The cutaneous layer of the fruit, perhaps peeled off in sections, becomes the component structure of the stencil-like letters.

In their hands, machines are not unfeeling objects carrying out functions and tasks with perfect detachment. Rather, there is an essential human aspect to the machines as well. (A *kana* version of Doris Orange was created by the Japanese designer Maniackers.) Both of these designers are recent graduates despite the extent of their professional endeavors. Not unlike other young designers, Haust and Fürst have been actively engaged with typography from the start of their design careers, seeing it as a direct means to realize their design goals and to articulate their identity. It's quite miraculous to think that most young graphic designers now produce a host of fonts. It suggests that working with typography is one of the most useful aspects of the formative process.

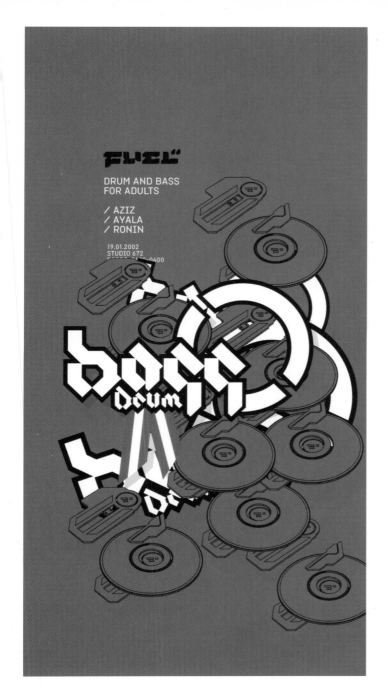

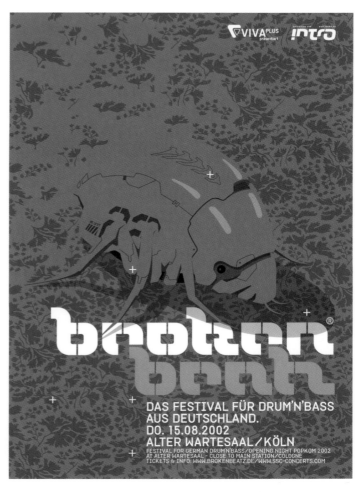

Drum 'n' Bass

Above, left: This mixture of high-tech elements and rustic Austrian folk aesthetics is for a flyer for a drum 'n' bass party (2002), featuring an Austrian DJ. *Above, right:* Poster and flyer for a drum 'n' bass festival, Broken Beatz (2002), at the Popkomm music fair in Cologne. *Right:* German Grammar CD for the UK drum 'n' bass magazine *Knowledge*.

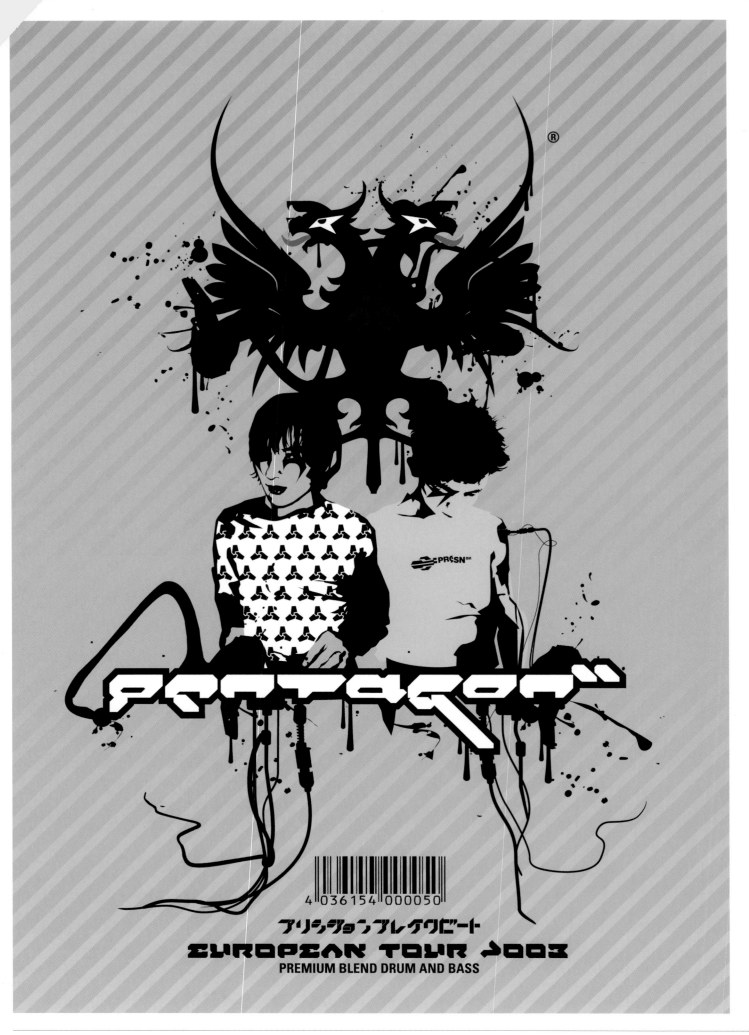

Illustration

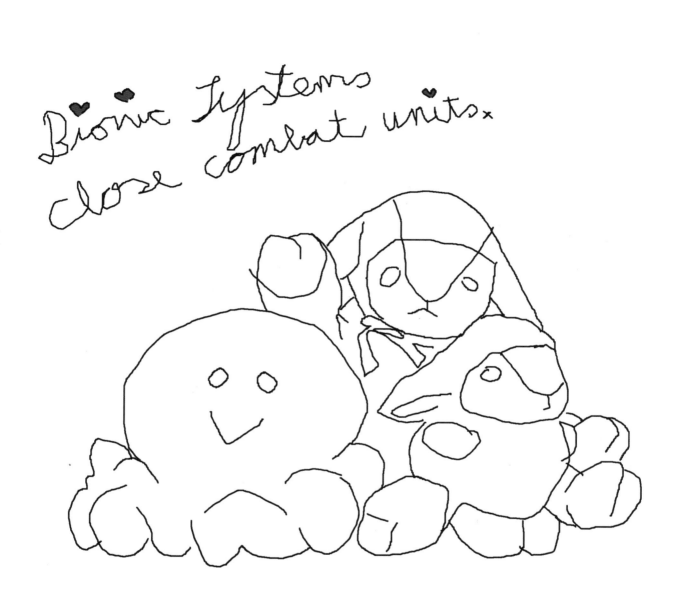

Bionic Systems
close combat units.

BIONIC CHARACTERS

Opposite: Flyer for the European tour (2003) of the Japanese
drum 'n' bass duo "Pentagon." *Above:* Mascot characters of
Bionic Systems (2002).

Bionic Systems 077

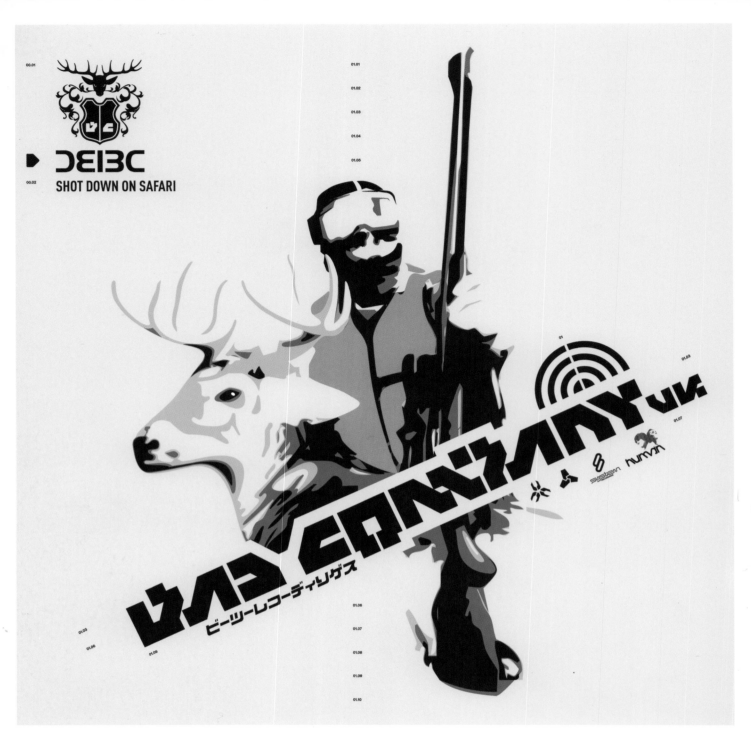

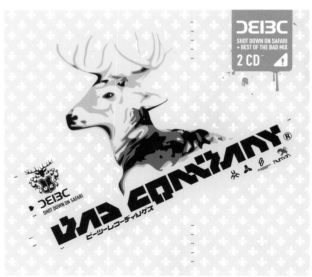

Opposite: CD artwork for the US "Shot Down On Safari" CD of UK-based drum 'n' bass act "Bad Company." Bionic Systems quips, "We thought it would be fair if the hunter is the one who was 'shot down on safari'." (2002). *Right and below:* 12" album cover designs for the German drum 'n' bass label "Precision Breakbeat Research" (2001 and 2002 respectively).

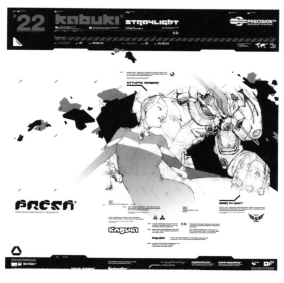

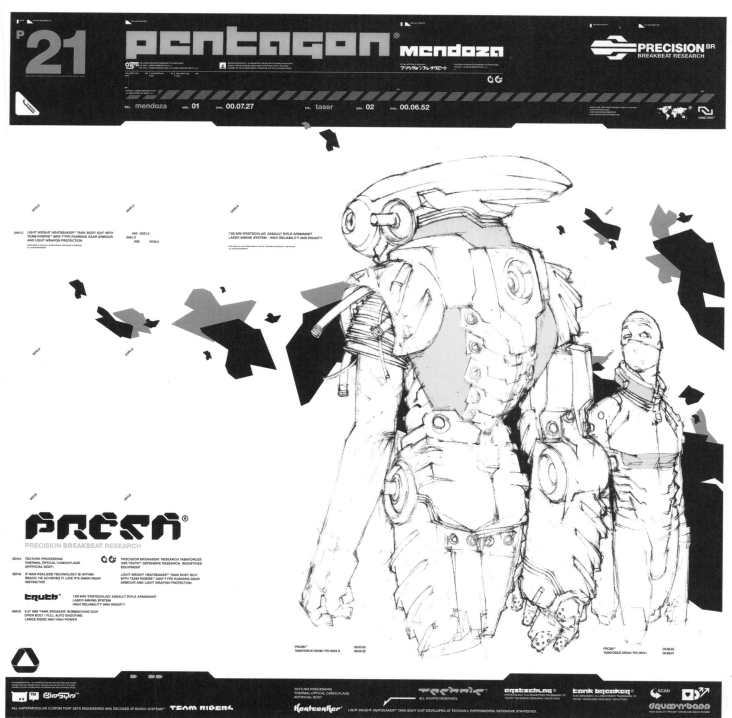

digital táctico

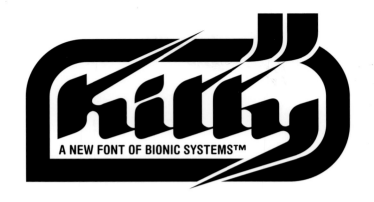

A NEW FONT OF BIONIC SYSTEMS™

3D

SIMILIS ®

AS/REC

PREHM & ARENDT ®

bytemission ®
mac system services.

FUEL™ PRECISION FRANKFURT

D10 Solutions AG

Biosys® Probe Unit
バイオニック・システムズ
A 0759

DISLOC
Digital Security
Logistics and Operations Center

PRCSN BR

Bionic Systems.

ULTIMO RATIO®

AMCN ®
KINETIC TECHNOLOGIES

SCHT ®
ACTION COMPANY

ENTERTAINMENT

phin ware

CONNECTIONS™


CORPORATE LOGO DESIGN
Various logos designed by Bionic Systems combining logotype and graphic illustration.


Several of the typefaces have developed out of working primarily with graphic illustration. Even used on their own, the typefaces evoke an illustrative feel.

Heatseeker®

Neo Tokio® Sporty®

Technik® Interfacer®

Doris Orange®

Cyberwar® Alphabot®

ÜBERFORM® Regular Array 1.0®

TEAM RIDERS®

0.1 Mb Truth® COMSAT®

Kernfusion®

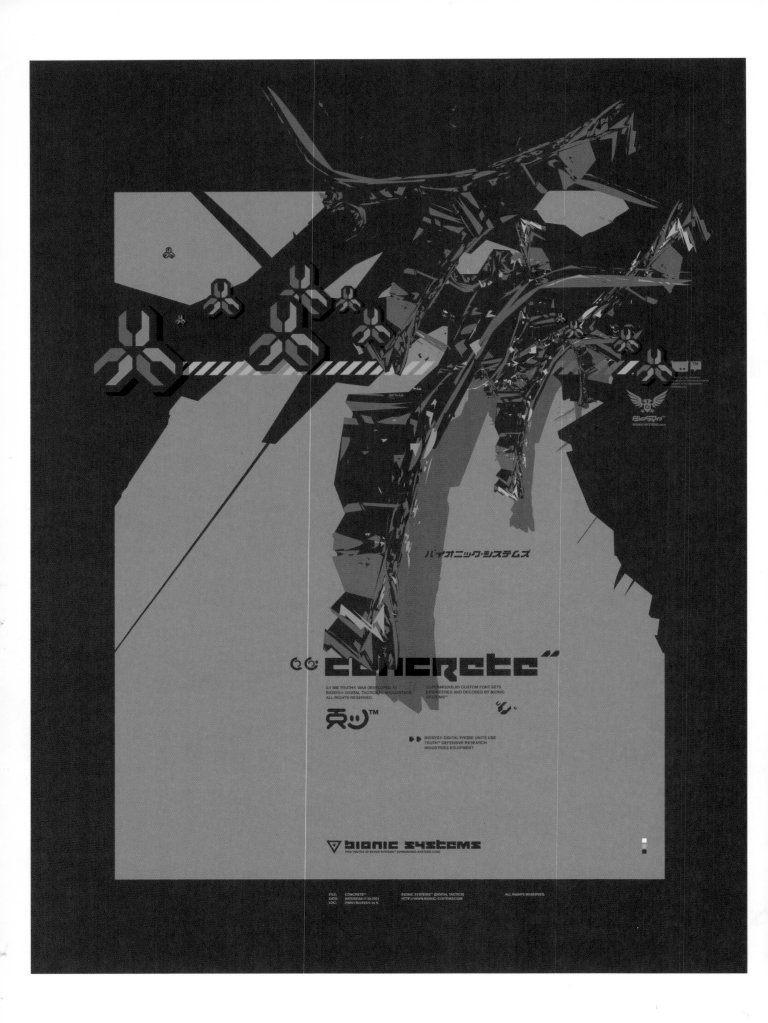

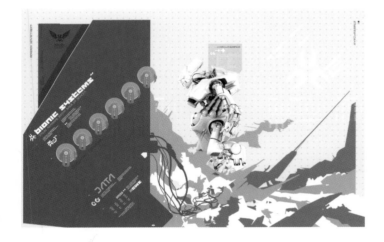

CONCRETE

Opposite: Poster design by Bionic Systems for the music event "Concrete." The triangular graphic is the logo for the design duo and is reminiscent in form to a biohazard warning symbol. Similarly, the theme of the poster itself signals the destructive potential of such materials to objects of a robotic nature. In the foreground, a concrete slab is ruptured by incisions made by the Bionic Systems logo. *Top* and *right:* CD package design. *Above:* Screenshot from the Bionic Systems website.

DAINIPPON TYPE ORGANIZATION

Over the last century, the infiltration of English and Western culture into that of Japan has been extensive—a trend that has become all the more pervasive since the Second World War. Though many aspects of this foreign culture have embedded themselves deeply in Japan's own, there remains a strong awareness of their foreign nature. In terms of writing systems, English and Japanese mix about as well as oil and water. Any combination of the two more often than not seems forced. At best, English gets "interpreted" into Japanese. Picking up on this tendency, the Japanese group Dainippon Type Organization puts this process into graphic practice. They converted the Chinese character for "tooth" into a grid, by fragmenting the individual strokes into component line segments (pages 086–087). Here, as with early digital clocks, filling in different combinations of the segments produces derivative letterforms. These comprise an alphabet and kana (Japanese syllabary)—appropriately named Dentypo.

The design group's parodies of well-known logos (pages 090–091) follow a similar vein. Using the form of the graphic itself, Japanese *kana* letterforms are etched out.

The segments of the *kana* letterforms, which spell out the name of the brand name in Japanese, are manipulated and rearranged to recreate the basic silhouette of the brand's logo. Imagine the letters N-I-K-E squeezed to fit into the brand's swoosh; Dainippon Type Organization has done this with Japanese names and logos. The greater message that they wish to convey is that logos contain a language like any formal written language.

In their experimentation with new graphic letterforms, the designers have also put to interesting use the pictographs and ideographs that comprise *kanji* (Chinese characters used in Japanese). By nesting the letterforms into the pictographs and vice versa, they have articulated something fundamental: despite the component-based nature of words (made up of individual letters), the entire assembly can be read as a single autonomous unit. Some words are more readily identifiable simply because of their repeated use and familiarity—as is the case with logo marks. Such words may be identified on a purely visual or graphic basis. Thus, a page of text can be perceived as a sequence of discrete graphic elements that make up one large graphic composition.

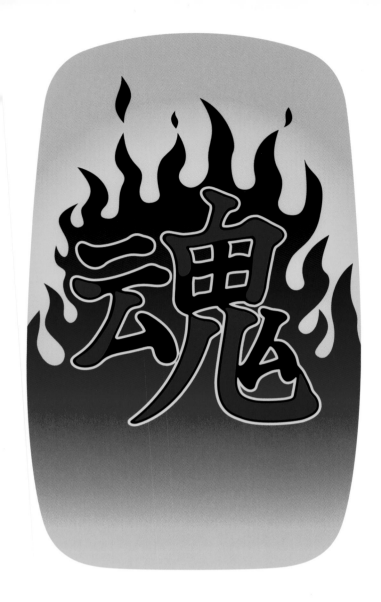

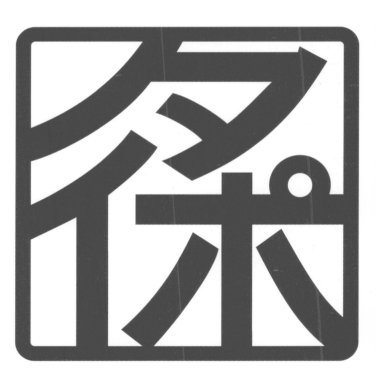

THREE WORD-PLAY GRAPHICS

Above left: The Chinese character for *tamashi* is in black and has been overlaid with its English equivalent "soul," written in purple using *katakana*. *Above, right:* The expression *ichiban* (meaning "number one") has been written in *katakana* but configured in the shape of the original Chinese character: 一番 . *Right:* The Dainippon Type Organization logo has the form of an *inkan*, a typical Japanese seal. The logo is a graphic play on the letters used to spell out their team name.

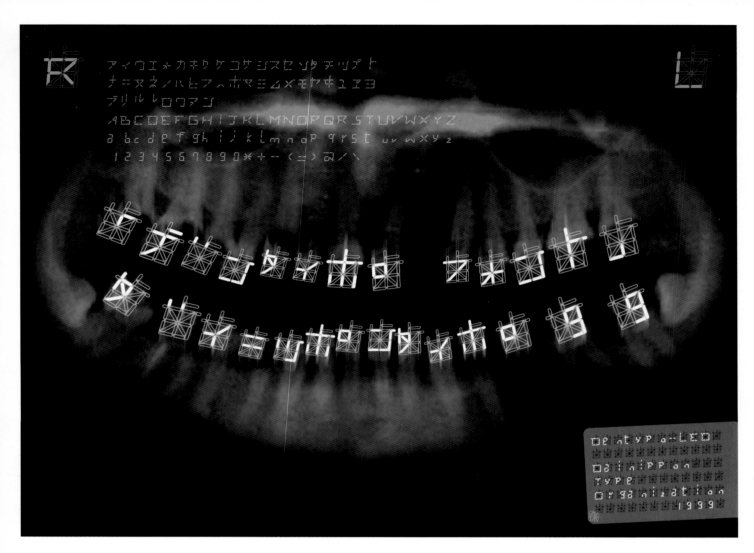

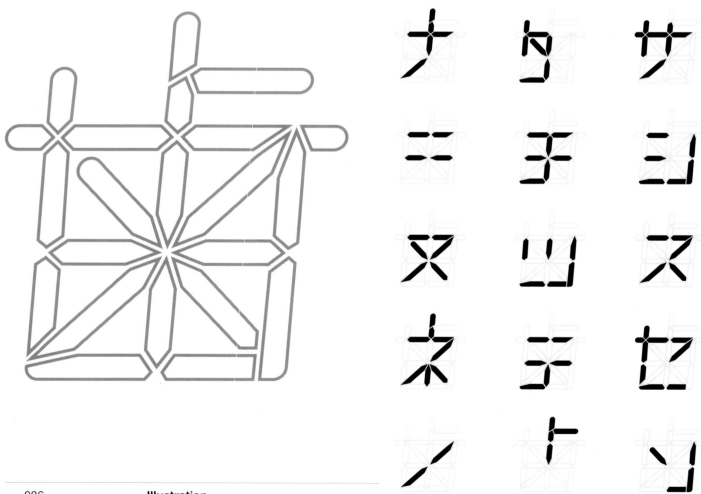

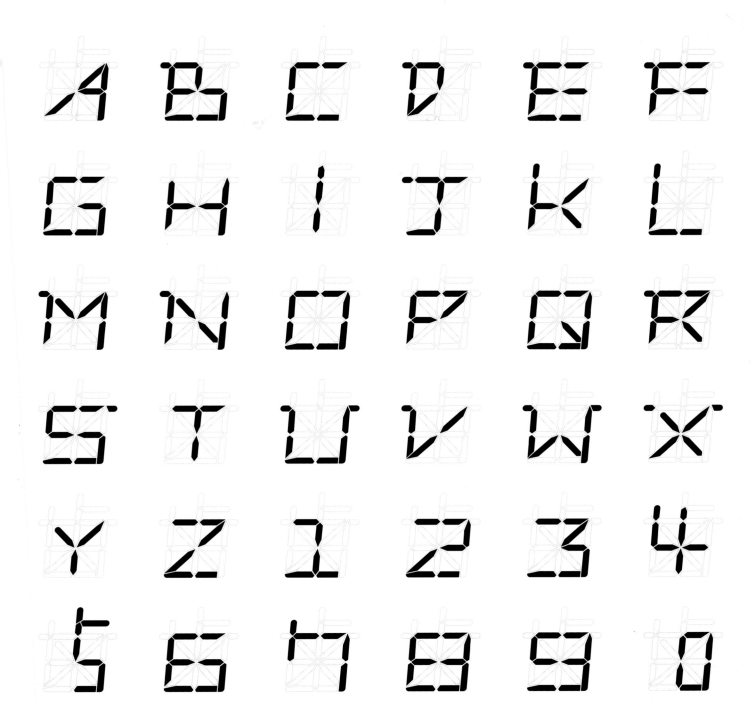

DENTYPO

The Chinese character for "tooth" is used as a format for creating derivative letterforms. *Opposite, top:* The designers have placed their constructed tooth-letters back into the mouth, as this adulterated X-ray demonstrates. *Opposite, left:* The letterforms are constructed on this shape. Its multiple strokes and complexity of form allow for a variety of sub-forms, thanks in great part to the asterisk-resembling radical (character fragment) that is in the center of the character. This radical represents rice. *Opposite, right:* Examples of how *kana* are written using Dentypo. *Above:* A similar example using the alphabet.

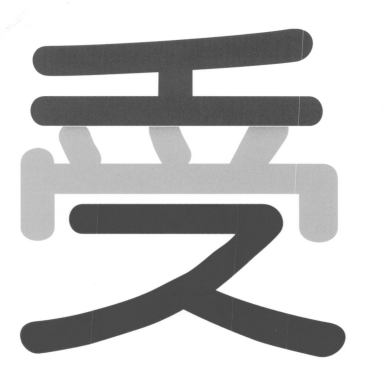

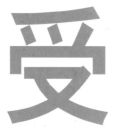

Chinese character

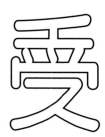

Hybrid letter

Chinese character

Hybrid letter

KUROFUNE

The name of this font means "black ship" and alludes to the first vessels that penetrated Japan's prolonged period of self-isolation. The font itself represents the confluence of Western and Eastern reading systems. Just as the ambassador ships brought with them the influence of a foreign culture, this font similarly belies a Western infiltration into contemporary Japanese. *Above, left*: This is the letter "X" of the typeface. It has a hybrid nature: each letter of this alphabet has been written using a complex structure comprising *katakana* (one of the Japanese writing systems). As in the example shown, the letter "X", when pronounced using the Japanese phonetic system, sounds like "ë-ku-su". Each of these fragments (represented by colors) is written in *katakana* and then arranged into a grid format based on *kanji* (Chinese characters). In this example, the form of the character for *ukeru* (receive) is used as the basis for the resulting composition. *Above, right*: the hybrid letter for the number 9. *Left*: examples of how the primary character form serves as the basis for the hybrid alphabet forms. *Opposite*: the full alphabet (in black) and numerals (in red).

ENJOY

Above: "Enjoy" transliterated into Japanese and written using *kanji*. The *kanji* has been warped to follow the form of the Coca-Cola logo. *Opposite:* "Nike" is written in *katakana* and has been given the form of the original logo mark.

Screen

With screens and displays popping up everywhere in portable music devices, wristwatches, optics, and other gadgets yet to penetrate the mass market, typography has been given a fresh challenge. The new media has its particular requirements: speed, compactness and simplicity. Within the development of letterforms for these devices, we find a whole new realm in which to explore typography, as demonstrated by the work of a Swiss designer and that of a Japanese typographer specializing in fonts for the web. Also in this section, we see the main titles of several major Hollywood movies. Though the size of the screens are on different orders of magnitude, they share their moving-text nature. These titles are powerful examples of how typography has a vital, graphic power on a par with moving images.

FONTGRAPHIC

IMAGINARY FORCES

Movie titles and opening credits play an important role in the feature presentations they introduce. They set the mood, facilitating the audience's smooth entrance into the world created by the film. Film credits and title sequences are also one of the best devices for introducing new uses of typography to a receptive audience. Imaginary Forces is a multi-disciplinary design and entertainment firm, based in Los Angeles, that has created award-winning work for several, diverse industries (including entertainment, advertising, and architecture). They've also produced movie titles for a vast number of Hollywood's blockbuster films. The work reproduced on pages 095–097 comes from Karin Fong, one of Imaginary Forces' creative directors, and Kyle Cooper, a former creative director and partner at the company.

For the film *Dead Man on Campus*, Fong picked up on the collegiate theme of multiple-choice exams—offering grim options of ways to kill yourself correctly: a "Suicide Aptitude Test." Among the ironic exam questions, fill-in-the-blanks, diagrams and charts is nestled the information we expect in movie titles: names of producer, director and cast. The humor of the sequence, jarring and dark as it is, is in the absolutely faithful reproduction of the test style and format, established decades ago and still unchanged. For Western audiences, the format and illustrations are immediately (and perhaps painfully) identifiable.

The title sequence for *Clockstoppers* was also directed by Fong. Central to this sci-fi film's plot is a watch that can manipulate the laws of relativity to create "hypertime." The title sequence is a journey through the workings of various timepieces, and the letterforms are animated to suggest different time-telling mechanisms. The type itself rotates like clock hands at one point and, in another segment, swings like a pendulum (pages 098–099). Cooper's titles for *Spider-Man* create an entirely different world. Here, the molecular biology that transforms Peter Parker into a superhero is integrated with the pattern of a spider's web. The letters, which are given three-dimensional form, are literally caught in the web.

As Cooper explains, type is only one important element in the total world created by Imaginary Forces. Because of the nature of film, title-creators can work with motion as well as still graphics. The letters fade, shift, move— indeed, they rarely sit still. For the viewer, there are no lengthy strings of text to digest; rather, small bites are shown in succession. Most importantly, since the types are made for specific use, the team has a great deal of freedom with each idea. They can rely on auxiliary data available to the viewer (either in the visual plane itself, or as background information) to facilitate legibility and comprehension. The audiences are often already familiar with the title and names, which means that the creators are no longer constricted by the need to make the typography easily legible, allowing more freedom to play.

Directed by

Alan Cohn

2a) This movie stars:

(A) Tom Sawyer
(B) Tom Jefferson
(C) **Tom Everett Scott**
(D) Tom and Jerry
(E) Tom Foolery

a) **Lochlyn Munro**

b) **Randy Pearlstein**

c) **Corey Page**

step 1

descent / time

Mark-Paul Gosselaar

If you took 23 aspirin tablets in 3 minutes, how many min would it take to swallow a family-sized bottle of pills? (Assume a constant rate)

Casting by **Deborah Aquila, C.S.A**

Jane Shannon-Smit

(A)　　　　　(B)　　　　　(C)

fig. 23 Story by
**Anthony Abrams &
Adam Larson Broder**

CO_2

Note: Figure not drawn to scale

DEAD MAN ON CAMPUS

Pages 095–097: Designed and produced by Imaginary Forces.
Creative Director: Peter Frankfurt; Art Director: Karin Fong;
Designers: Karin Fong, Adam Bluming; Illustrator: Wayne Coe;
Copywriters: Adam Bluming, Karin Fong; Editors: Doron Dor,
Kurt Mattila, Larry Plastrik; Inferno Artist: Jim Goodman;
Head of Production: Saffron Kenny; Producer: Maureen
Timpa; Studio: Paramount; Director: Alan Cohn.

Costume Designer **Kathleen Detoro**

Film Editor
Debra Chiate

6. For best results: (A) Bake
(B) Broil

Director of Photography =
John A. Thomas

IN #1 → **C** ← TRAIN #2

ON TO THE NEXT LIFE

If you
in 3
woul
a fam
(Assu

section 2: What comes next in this sequence?

(1) (2) **(3)**

DEAD MAN ON CAMPUS

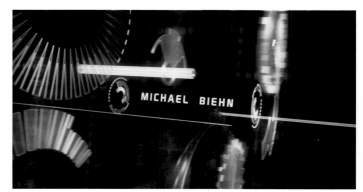

CLOCKSTOPPERS

Designed and produced by Imaginary Forces. Creative Director: Karin Fong; Art Director: Chris Lopez; Designers: Karin Fong, Chris Lopez, Chun-Chien Lien, Peggy Oei; Lead Animators: Chris Lopez, Chun-Chien Lien; Animators: Grant Lau, Jason Doherty; Editor: Carsten Becker; Editorial Assistant: Justine Gerenstein; Inferno Artist: Clyde Beamer; Producer: Keith Bryant; Coordinators: Ben Apley, Martha Smith; Studio: Paramount; Director: Jonathan Frakes.

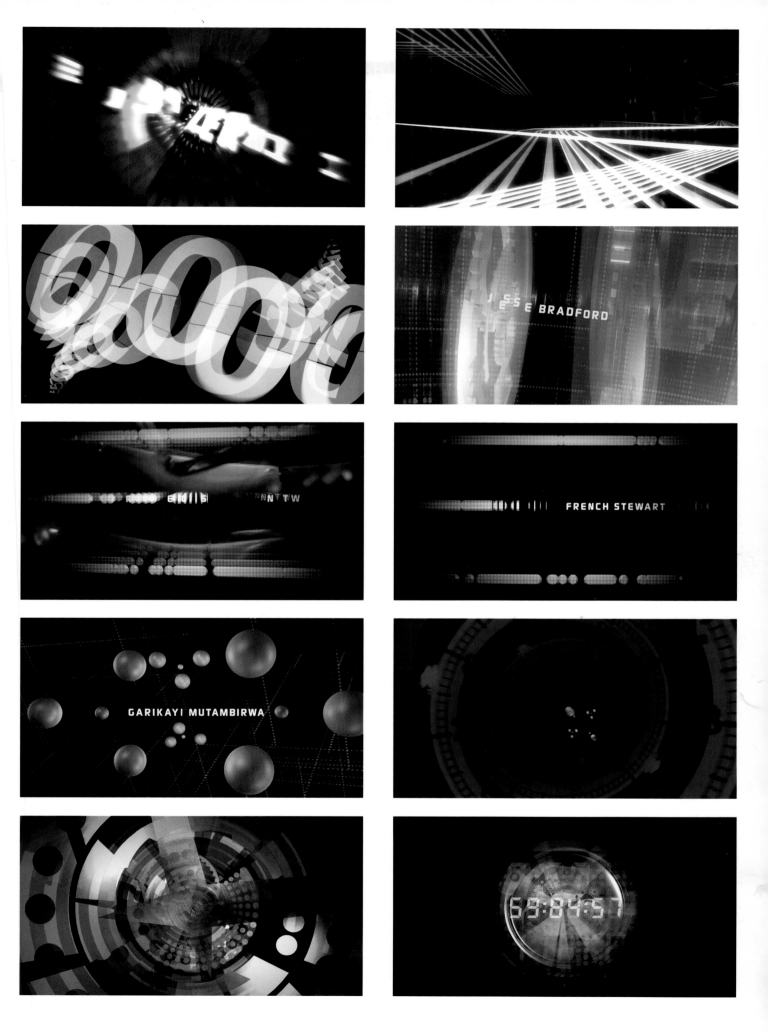

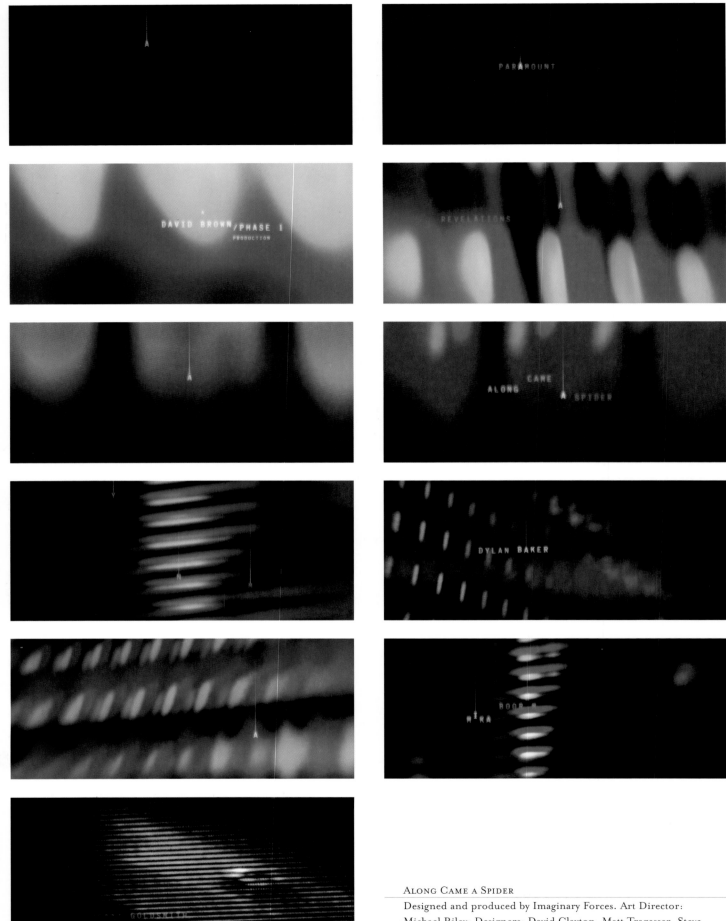

ALONG CAME A SPIDER

Designed and produced by Imaginary Forces. Art Director: Michael Riley; Designers: David Clayton, Matt Tragesser, Steve Pacheco; 2D Animator: Matt Tragesser; Editor: Tony Fulgum; Inferno Artist: Clyde Beamer; Head of Production: Saffron Kenny; Producer: Gina Galvan; Coordinator: Eva Prelle; Studio: Paramount Pictures; Director: Lee Tamahori.

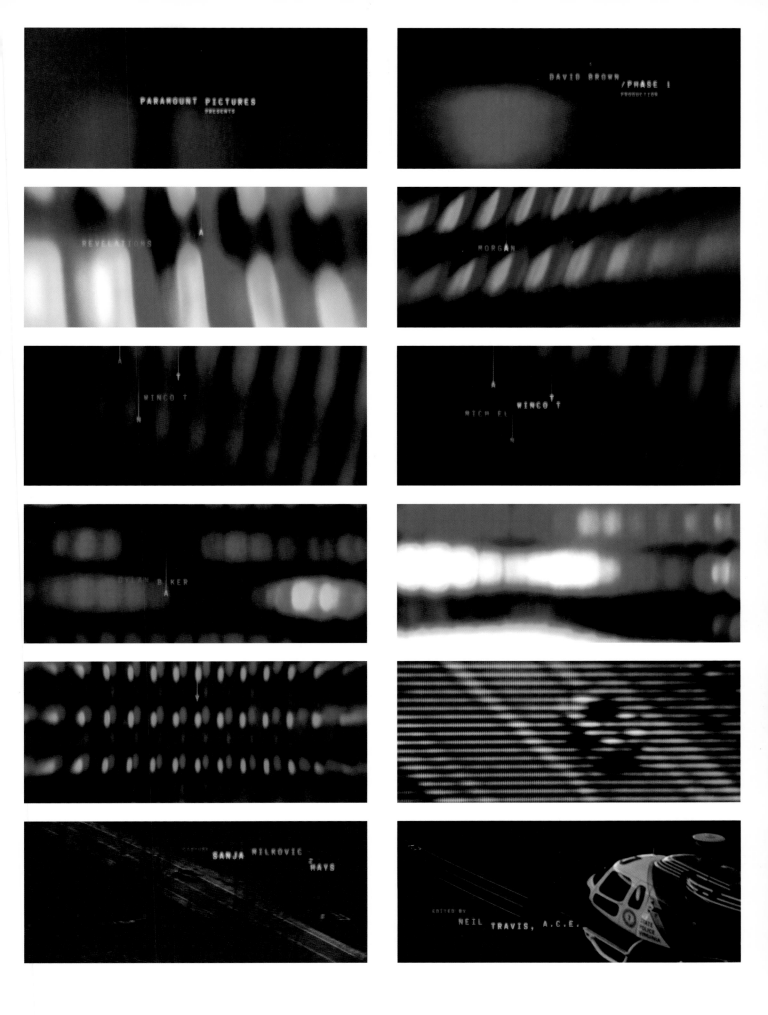

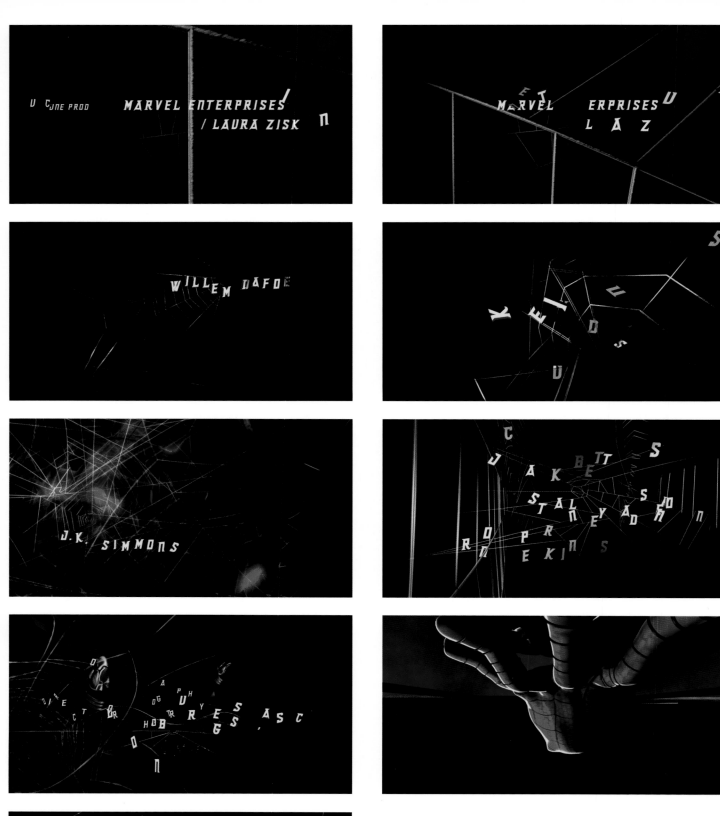

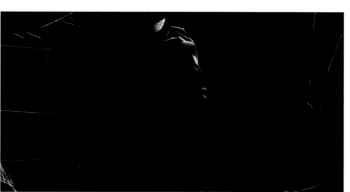

SPIDER-MAN

Designed and produced by Imaginary Forces. Title Sequence
Director: Kyle Cooper; Designers: Kyle Cooper, Charles
Khoury, Ahmet Ahmet, Ben Lopez; 3D Animators: Charles
Khoury, Asa Hammond, Ben Lopez; Editor: Carsten Becker;
Inferno Artist: Rod Basham; Post Production Supervisor:
Clyde Beamer; Executive Producers: Peter Frankfurt, Chip
Houghton; Producers: Phyllis Weisband, Keith Bryant;
Coordinators: Ben Apley, Jon Berkowitz; Studio: Columbia
Pictures; Director: Sam Raimi.

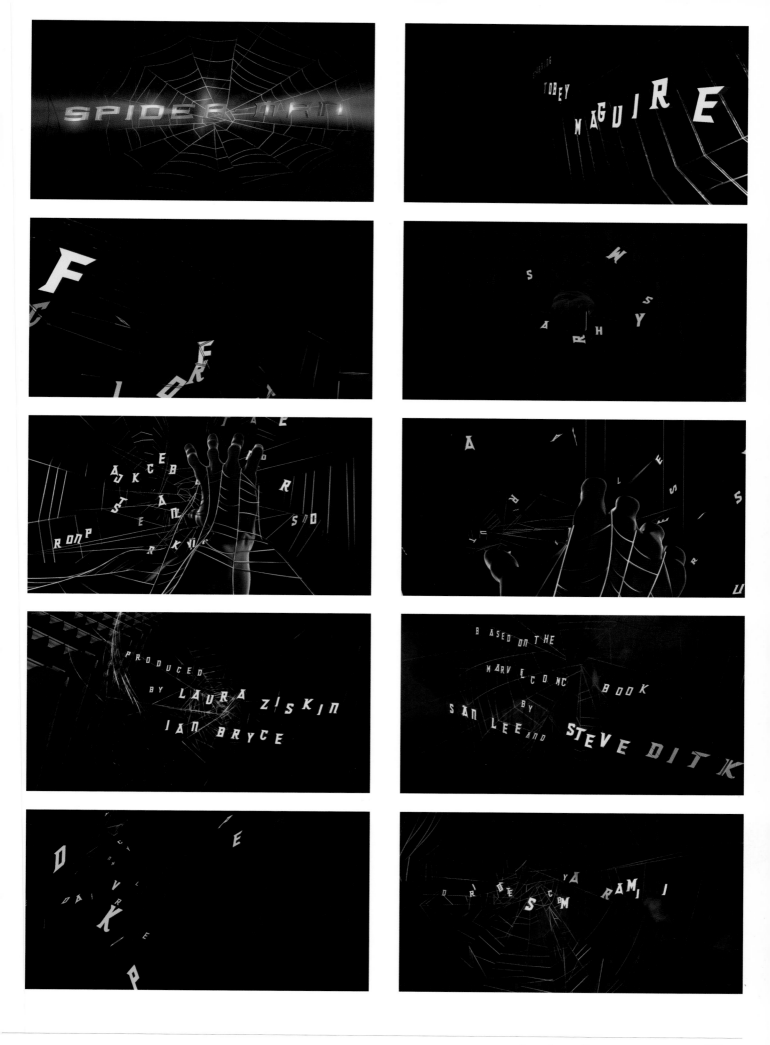

BICENTENNIAL MAN

Designed and produced by Imaginary Forces. Creative Director: Peter Frankfurt; Art Director: Mikon van Gastel; Designers: Matt Checkowski, Mikon van Gastel; 2D Animators: Matt Checkowski, Jennifer Lee; Editor: Jason Webb; Inferno Artist: Nancy Hyland; Head of Production: Saffron Kenny; Producer: Alexander Dervin; Coordinator: Christina Hwang; Studio: Columbia Pictures; Director: Chris Columbus.

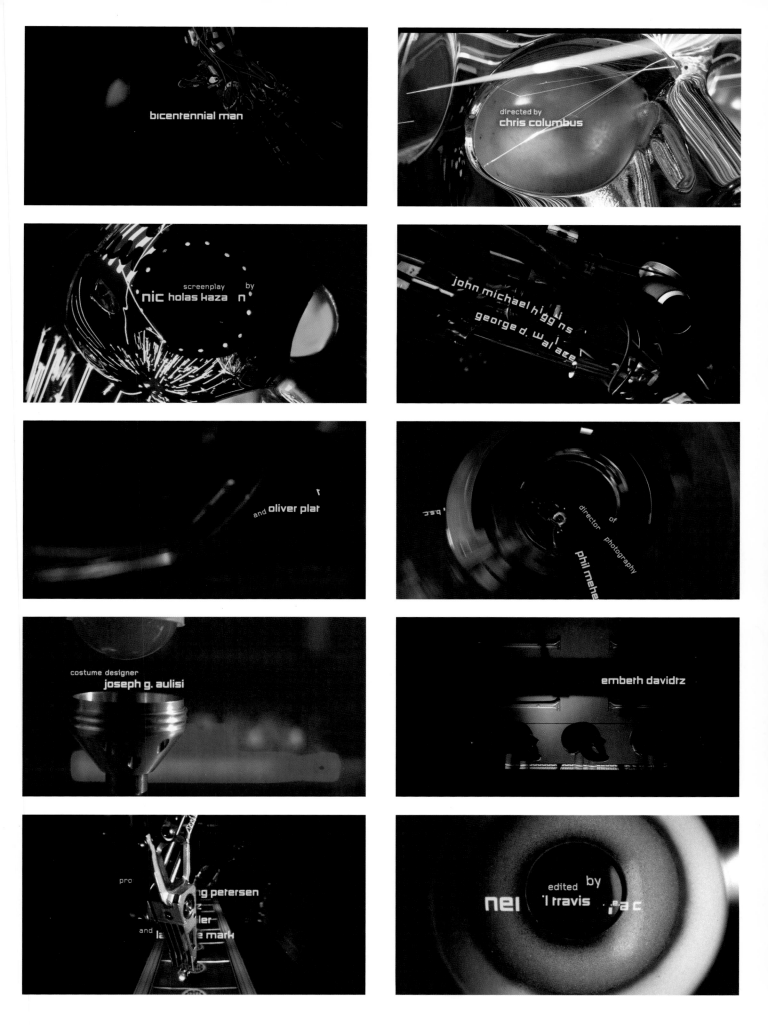

A PETERS ENTERTAINMENT /
SONNENFELD-JOSEPHSON PRODUCTION

IN ASSOCIATION WITH **TODMAN, SIMON,
LeMASTERS PRODUCTIONS**

A **BARRY SONNENFELD** FILM

KEVIN KLINE

BAI LING

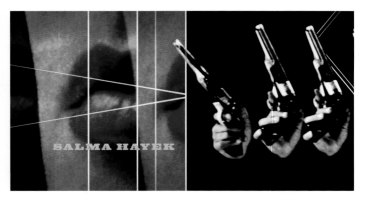

SALMA HAYEK

WILD WILD WEST

Designed and produced by Imaginary Forces. Creative Director:
Kyle Cooper; Art Director: Olivia d'Albis; Designers: Olivia
d'Albis, Sara Marandi, Kyle Cooper; 2D Animators: Calvin
Lo, Earling Mo, Sara Marandi; 3D Animators: Sara Marandi;
Editor: Mark Hoffman, Jason Webb; Executive Producer:
Peter Frankfurt; Head of Production: Saffron Kenny;
Coordinator: Keith Bryant; Studio: Warner Brothers;
Director: Barry Sonnenfeld.

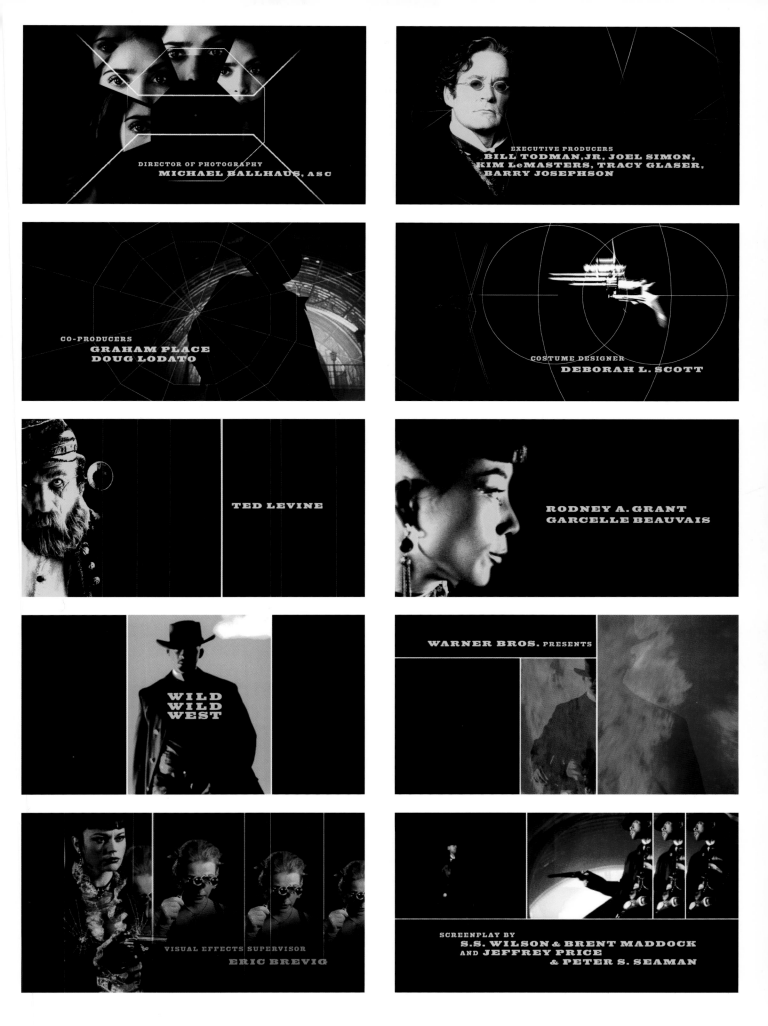

DIRECTOR OF PHOTOGRAPHY
MICHAEL BALLHAUS, ASC

EXECUTIVE PRODUCERS
**BILL TODMAN, JR, JOEL SIMON,
KIM LeMASTERS, TRACY GLASER,
BARRY JOSEPHSON**

CO-PRODUCERS
**GRAHAM PLACE
DOUG LODATO**

COSTUME DESIGNER
DEBORAH L. SCOTT

TED LEVINE

**RODNEY A. GRANT
GARCELLE BEAUVAIS**

**WILD
WILD
WEST**

WARNER BROS. PRESENTS

VISUAL EFFECTS SUPERVISOR
ERIC BREVIG

SCREENPLAY BY
S.S. WILSON & BRENT MADDOCK
AND **JEFFREY PRICE**
& PETER S. SEAMAN

FIDEL PEUGEOT

Despite his deep engagement with digital media and wireless devices, the multitalented Swiss typographer, designer and artist Fidel Peugeot is generally disposed to working with pen and paper. Peugeot's work creating a handwritten digitized font collection Die Gute für Alle (The good for everyone) led Wallpaper* magazine's Art Director Herbert Winkler to commission him to create typefaces for the sports journal Line and the fashion magazine Spruce. How the designer's involvement with the analog methods of drawing, writing, composing, and crafting came to be transferred to industrial and concept design for wireless devices is curious, and, as Peugeot explains, fortuitous.

Before his magazine commissions, Peugeot had been active developing fonts for Telepong. With collaborator Karl Emilio Picher, he is currently developing their first device, the Boomerang, a handheld keyboard panel meant for wireless text messaging. The so-called Telepong-Copy is a screen-optimized pixel font family for interface (pages 112–113). On-Off (pages 113) is a pixel headline font family for the company's website interface.

LCD display screens—so prevalent on phones, wristwatches and audio devices—provide another medium for typography. In the process of creating Telepong, a secondary set of images was generated for LCD (page 112); these other images are oddly reminiscent of line drawings, despite their bitmap nature.

With the advances in multi-button functioning, interface design, and minimal text messaging, the media through which type is read are yet further removed from ink and paper. To what extent, then, do digital media bring to bear their own standards and rules for typography? The varied digital typefaces Peugeot has generated—some of them designed strictly for use as web fonts—signal a new aesthetic in type design. Perhaps this is start of a new Gothic style.

Peugeot is also a co-founder and art director of the Lomographic Society (producers of the Lomo camera). The Lomo Society has now expanded its operations to include manufacturing, design, a picture archive and a travel agency. The Lomo fonts have similarly undergone an expansion, despite comparatively crude letterforms, to what Peugeot calls the "Font Dynasties." There are five font-families: LomoWall, LomoSamples, LomoWeb, LomoCopy and LomoAS Action Sampler. (They are available as shareware at www.lomofonts.com.) Each comprises 220 characters or more. All of the fonts adhere to the demands of the web, with a low 72-dpi resolution. As such, they work neatly with the proportions of the Lomo photograph format itself: 7 x 10 cm. But these pixel fonts aren't necessarily restricted to screen usage. Unlike the mutilated fonts of which contemporary type designers tend to be so fond, these digital fonts hold to both the rules of legibility and the limitations of technology. The typefaces are crisp and lend themselves to high contrast. Serifs are out. Even diagonal lines are seen as stumbling blocks.

But technology has other limitations as well, as Peugeot points out. "Monitors are false friends," he says. "Sitting face to face with them can make you tired and an addict, just like drugs. The computer is hopefully only a temporary solution, helping us eventually to return to handicraft, since manual activity allows the mind the most freedom to act."

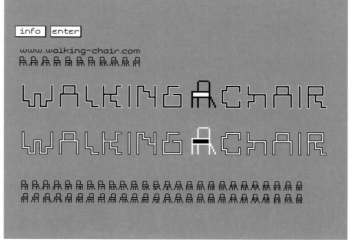

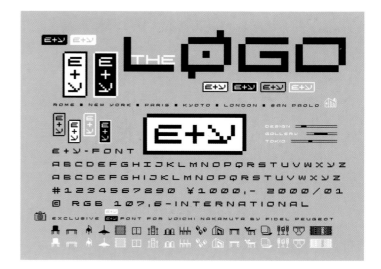

WALKING CHAIRS AND LOGOTYPES

Top: Walking Chair is one of the product design projects with
which Peugeot is involved—the chair does actually walk! It has
also given its name to the new venture Peugeot has initiated with
Picher: Walking-Chair Design Studio GmbH. *Center:* The
graphic here is the top page for the product's website. *Right:*
Peugeot designs many custom typefaces, including the logotype
for magazines such as *Wallpaper**. The example here is a type
sample for the client E&Y (Japan).

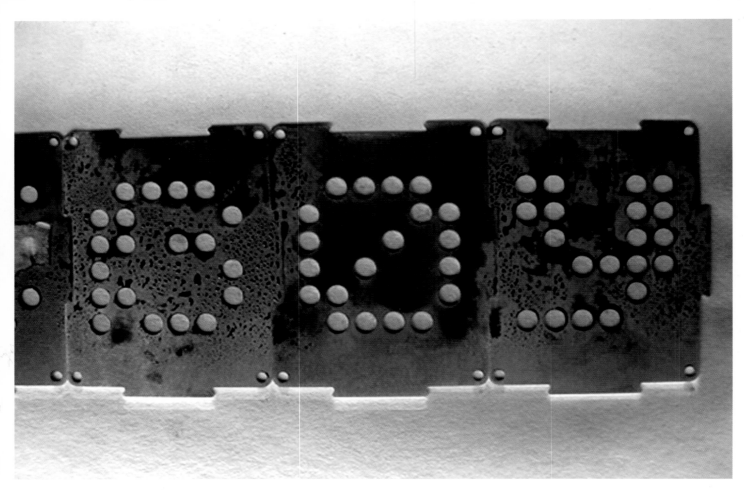

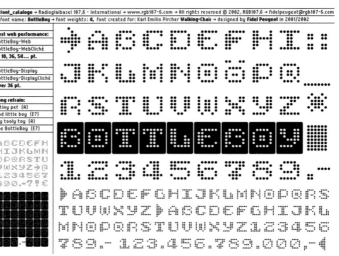

BOTTLEBOY

This typeface began in an unassuming manner (*opposite, above*). The punch holes made in the pliable styrofoam contrast with the cut-metal puzzle pieces (*opposite, below*). The use of different materials is the designer's way of seeing the typeface freed of any one particular medium (whether it be two- or three-dimensional). The design of the typeface expands upon Peugeot's other typeface designs for screen display, borrowing the concept of the base grid.

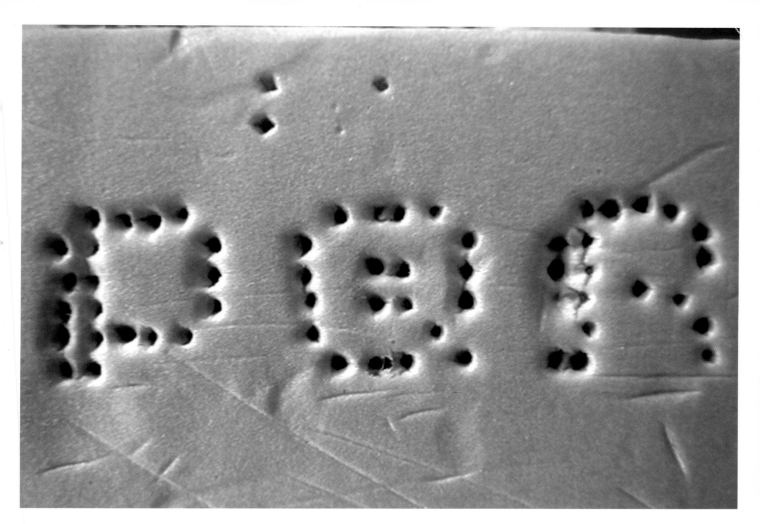

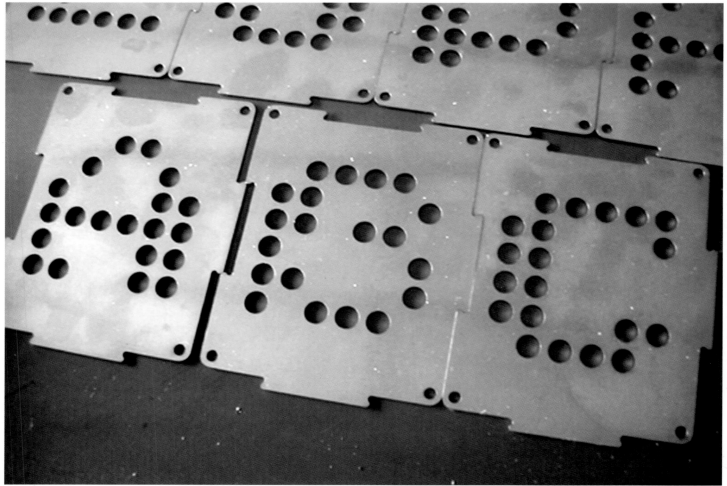

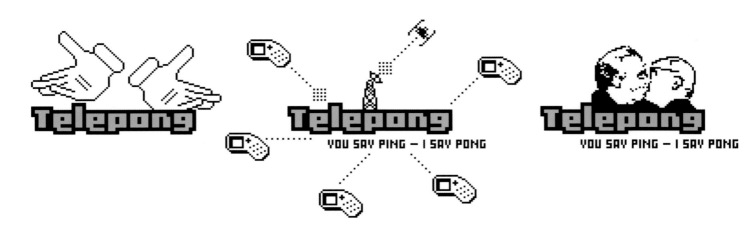

Mikrofon Babyfon Minifon Autofon Dictafon Dudafon
Megafon Gigafon Sugafon Grammofon
Hanofon Nettofon Vibrafon
Mutafon Ottofon Extrafon
Sodafon Limbofon

T-FON IS A HEADLINE FONT FOR TELEPONG
IN- & OUTLINE WEIGHTS ARE MADE TO MASURE

T-Font

T-Font: 10 pt., 20 pt., 30 pt., 40 pt., 50 pt., 60 pt., 70 pt., 80 pt., 90 pt., 100 pt.

»T« for Telepong Headline

Mikrofon Babyfon Minifon Autofon Dictafon Dudafon
Megafon Gigafon Sugafon Grammofon
Hanofon Nettofon Vibrafon
Mutafon Ottofon Extrafon
Sodafon Limbofon

72 pt. Telepong ▶Strip ▶Copy

72 pt. Telepong ▶Strip ▶Copy

24 pt. Telepong-Copy.Reg @abcdefghijklmnoopqrstuvwxyz
#123.456.789.000,– ABCDEFGHIJKLMNOPQRSTUUWXYZ!?

12 pt. ■Telepong/TELEPONG-Regular
ABCDEFGHIJKLMNOPQRSTUUVWXYZ
abcdefghijklmnopqrsßtuvwxyz.
#123456789"0'€£@◎©←→▸(T):

■TELEPONG/Telepong-Strip.Regular
ABCDEFGHIJKLMNOPQRSTUUVWXYZ
abcdefghijklmnopqrsßtuvwxyz.
#123456789"0'€£@◎©←→▸(T):

24 pt. Telepong-Copy.Bold @abcdefghijklmnoopqrstuvwxyz
#123.456.789.000,– ABCDEFGHIJKLMNOPQRSTUUWXYZ!?

12 pt. ■Telepong/TELEPONG-Copy.Bold
ABCDEFGHIJKLMNOPQRSTUUVWXYZ
abcdefghijklmnopqrsßtuvwxyz.
#123456789"0'€£@◎©←→▸(T):

■TELEPONG/Telepong-Strip.Bold
ABCDEFGHIJKLMNOPQRSTUUVWXYZ
abcdefghijklmnopqrsßtuvwxyz.
#123456789"0'€£@◎©←→▸(T):

On_Off 72pt.

On_Off 54pt.

On_Off-Font 36pt.

▸ On_Off-One 18pt.
ABCDEFGHIJKLMNOPQRSTUV
abcdefghijklmnopqrsßtuvwxy

TELEPONG

Telepong is a hand-held device that combines the function of
a mobile phone, PDA, and game-console. It is built with a small
screen that displays the content. The interface font was designed
by Peugeot. *Opposite, top:* The graphics are examples of the
symbols that were developed for SMS messaging.

A B C D E

F G H I J

K L M N O

P Q R S T

U V W X Y

Z 1 2 3 4

5 6 7 8 9

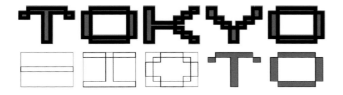

THE LOMO DYNASTY OF FONTS

This spread: Three examples of the many typeface weights of the Lomo font family.

FONTGRAPHIC

Japanese writing systems pose several problems for the creators of their digital font equivalents. The language has two syllabaries that are similar in form (one is more square-edged than its curvy counterpart), so in bit fonts their basic shapes become virtually indistinguishable. Also, *kanji* (Chinese characters used in written Japanese) is a composition of multiple strokes, ranging from one to about twenty—a great deal more complex than the minimal strokes of the alphabet. Designer and typographer Hideaki Ootani has created several fonts that address such issues, and has even taken on the task of digitizing *kanji*—a project he plans to complete in 2004.

Ootani's F2Script (page 121) is constructed with a dot matrix. The bottom line is extended in a mock-cursive style. (There is a bold version of this font, which simply doubles the horizontal weight of the letterforms.) In Japanese there is no "cursive" font that connects letters, so for the syllabaries this is a new form. Diagon (page 120) is constructed on a diagonal line; the overall letterform is at an angle, although the dot matrix that forms the letters is not. Ootani explains that Diagon came about as a result of designing with the computer.

The font FR is also built on a dot matrix. Here, the matrix cell centers are connected (page 121) to create the so-called "stroke font"—such fonts are made of centerline vectors, lines and arcs; Helvetica is the best-known example. (The main proponent of stroke fonts was Austrian designer Herbert Bayer, whose geometric, asymmetric style was key to the Bauhaus look.)

With the centerline vector and the simple connection of dots, this type of font lends itself particularly well to architectural plans, which require speedy rendering. FR's mutable shape and size allow it to replace the bitmap and thus be of use in mobile-device screens. It is a fusion of the stroke font and the dot-matrix font.

Denkotsubun (pages 118–119) is, in essence, the *kanji* extension of the FR alphabet and syllabary. It is constructed on a 12-by-12 dot-matrix frame. The dot placement relative to the interspacing is 1:2 and the dot centers are connected using only horizontal, vertical, and 45-degree diagonal axes. It has the features of an electronic scoreboard form, stroke font, and postscript font. The font's name derives from the word *kokotsubun* (inscriptions on animal bones and tortoise carapaces, used for fortune-telling in ancient China; see page 118). These carvings were originally made with knifepoint, and thus have hard-line forms. Subsequently, during Japan's Nara period, the inscriptions were made on thin strips of wood, and still later they were written with brush on paper. Throughout their evolution, the *kokotsubun* forms and decorative styles underwent a number of varied styles. Ootani's Denkotsubun references these primitive writings to comment on the primitive nature of bitmap faces now. Perhaps Ootani sees the current state of digital typefaces as letterforms roughly hewn, still to be refined—not unlike forms of the *kokotsubun*. Denkotsubun is thus a new generation in the endless lineage of letterforms.

The url for Ootani's website is www.fontgraphic.com.

電骨文

KOKOTSUBUN

Previous page: The oldest surviving records of *kanji*, which has a history of 4,000 years, are inscriptions on animal bones and tortoise carapaces (known in Japanese as *kokotsubun*). Fontgraphic designer Hediaki Ootani has rendered the outline form of one of these artifacts. Its original use is purported to be for fortune telling. After being marked, a hole was made and fire applied to create cracks in the bone or carapace. Depending on the position of the cracks and how they divided up the markings, the outcome of pivotal events was predicted. Ootani's font Denkotsubun is a play on the word *kokotsubun*, replacing *ko* ("shell") with *den* ("electricity"). *This spread:* Ootani's font resembles the ancient carvings in their rough, angular lines and corners. The construction of the font is done on a 12-by-12 dot-matrix grid. Vertical, horizontal and 45-degree diagonal lines are created by connecting the center points of each dot. The irony of these extreme fonts (intended for screen display) is that they resemble forms that predate history. The character rendered above is *ai* ("love"). *Opposite:* the first set of characters in the lexicon rendered in Denkotsubun.

亜唖娃阿哀愛
挨姶逢葵茜穐
悪握渥旭葦芦
鯵梓圧斡扱宛
姐虻飴絢綾鮎
或粟裕安庵按
暗案闇鞍杏以
伊位依偉囲夷

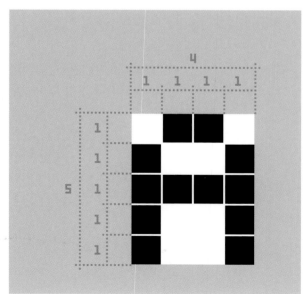

This page: Diagon. Though alphabet type is always designed to be used horizontally, Diagon is designed to be used at an angle. As in the enlargement below, each letter is built on a grid that is not itself set at an angle. Designer Ootani maintains that working in this way to create type would not have been possible (or even thought of) without computers. *Opposite, above:* An example of the frame used to create a "stroke font," the theory of which was put forward by Bauhaus designer Herbert Bayer. Helvetica is an example of this type of font. A stroke font is created using the center axis of the letter. This lends itself for use by XY plotters (as in architectural drawings) as the letter can easily and plainly be rendered using a single point. Given the size, versatility, and potential for alteration, this type of font has been appropriated for use in moving type. The type shown here is an amalgam of the stroke and dot fonts. *Opposite, below:* This is a script version of a bitmap typeface.

ABCDEFGHI
JKLMNOPQR
STUVWXYZ0
123456789
abcdefghij
klmnopqrst
uvwxyz

ABCDEFGHI
JKLMNOPQR
STUVWXYZ0
123456789
abcdefghij
klmnopqrst
uvwxyz

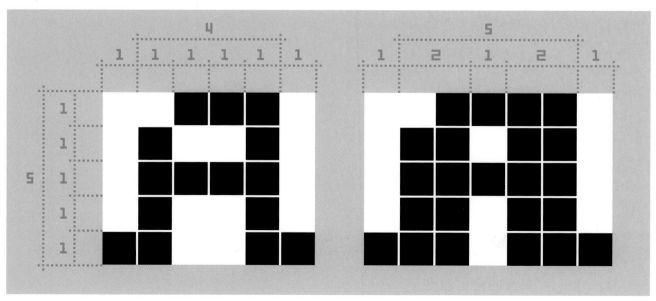

Dimension

SURFACE Page 124

CLOSE FONTS Page 130

Assembled in this section is work that considers the dimensional aspect of type. A German designer creates a theoretical construct relating type, architecture, sound and dance. Another German creative team manipulates letterforms to dramatic effect in three dimensions. A Swiss-design team creates an entire town out of type. They also render their national type, Helvetica, into mock-architecture. And finally, in the last case study of this section, the work of another Swiss design team presents their research of the multiple dimensions of letterforms.

BÜRO DESTRUCT Page 140

NORM Page 146

SURFACE

The graphic representation of acoustics or dance movement requires the transposition of one medium to another. The work of the Frankfurt-based design firm Surface deals largely with finding a connection between elements that operate in different dimensions. Their contribution to a group exhibition of site-specific works "Frequencies [Hz]: Audio-Visual Spaces" (held at Frankfurt's Schirn Künsthalle in 2002), was about creating links among three systems: architecture, graphics and sound. Surface developed a notation system to graphically represent the acoustics of each room in the exhibition (the show was designed by the architectural team Hirsch/Mueller). The resulting graphic (pages 126–127) represents a loop of sound. The series of peaks and valleys is translated into a graphic band of alternating tones, which then serves as a sound loop. This experimental transference of energy vibrations into visual language can be broadened to encompass other forms of "notation," including written language.

Surface's work with dancer Bill Forsythe's troupe is a similar process of transferring media. Influenced by the dancers' movements and gestures, the designers created forms developed from the dance sequences, representing movement in time within graphic notation. Sections of a dancer's body are integrated into the progressive morphing of the graphic forms, indicating the direction and extension of movement.

Surface's founder, Markus Weisbeck, relates this process of transferring media and their design principles back to Bauhaus theories—in particular, to the optic-phonetic systems of László Moholy-Nagy. In Weisbeck's case, however, the connection of acoustics and other media to design stems back to his former career as a DJ and his interest in electronic music. His years of collecting electronic music led to the publication of his research on the subject, and a book on which he collaborated with Karl Barthos, formerly of the German group Kraftwerk. This became the foundation for Weisbeck's design work, which began as flyers for the club where he was spinning tunes.

For Surface, acoustic, and other audio data serve as "pigments for a painter." Weisbeck concludes, "Connecting these different themes—music, sculpture, and graphics—brings you to a more holistic design."

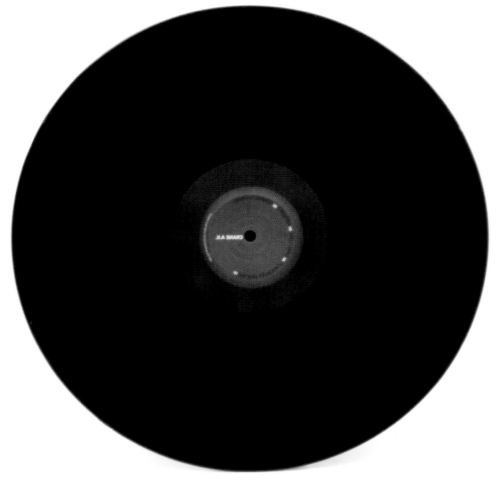

Dimension

FORCE TRACKS

Previous spread: Maxi sleeve album design for *Force Tracks*.

FREQUENCIES [HZ]: AUDIO-VISUAL SPACES

This spread: Design of exhibition "Frequencies [HZ]: Audio-Visual-Spaces" at the Schirn Künsthalle Frankfurt (2002).

Auch
KISS TOMORROW GOODBYE

Marc Ushmi meets Reverend Galloway
on Ernst Busch

AUDIO VISUALS

Opposite: CD cover art designs. *Above:* Corporate identity design
for three exhibitions by ICA Frankfurt. *Right:* Sleeve design.
(Photography by Trautmann/Wöller.)

CLOSEFONTS

What would happen if letters had dimension, texture, and movement? Simon Schmidt, of German design team Closefonts, uses a discontinued software called Typestry, with which he manipulates and experiments with letterforms in three-dimensions. His use of a transparent "texture" gives his letters multiple silhouettes as they fold over themselves, and redoubles their structure when they are rotated. As opposed to being spun on a central vertical or external axis, these letters are moved about on their trajectories in all coordinates. Without the use of this transparent texture, the three-dimensional simulation would obstruct our view of the inner "workings" of the forms. An "A", spun on its central vertical axis, for example, would look like a simple cone. The external surface would become a negative space—like the surface of a woodworker's spindle. With Schmidt's fonts, however, the letter exists in relief before any trajectory for the font is set in motion. This, in tandem with the transparent texture he applies, reveals the internal "workings". In one character, which Schmidt refers to as the "mad Q," there seems to be little resemblance between the three-dimensional graphic and the letter "Q". Simple letterforms become quite complex when another dimension is added.

The Typestry software was developed by Pixar, but has been unavailable since the late 1990s (around the time of Pixar's engagement with the movie industry). The program uses Mac Postscript fonts and transposes them into three dimensions, offering a variety of modification tools. The bevels, for example, use bezier curves that can be changed in any number of ways. Textures are extremely easy to alter, as is lighting. Through this experimentation, as the letters move along a path, the essential structures of the letterforms are glimpsed. This gives a greater sensitivity to the composition of the form and how it functions in space relative to itself. In other words, the area contained within the enclosure of an "E" creates a volume when put into three dimensions. This simple animation leads one to wonder about the overall organization of the space within letters. Once this visualization is enabled, it's difficult not to wonder about a letter's spatial organization—in both two and three dimensions. Schmidt's use of the software began with translating clients' logos into three dimensions.

Experimenting with type has produced several sets of results, including those illustrated here. On page 136 are examples of the graphic uses of the letter "M" in Schmidt's font OGRA. He calls the texture "frozen blood." This is a side of the letter "M" that is seldom seen. Though the renderings may not be legible enough to function within a text, Schmidt's main concern is to get a greater feeling for and understanding of the letterforms that we are so accustomed to seeing.

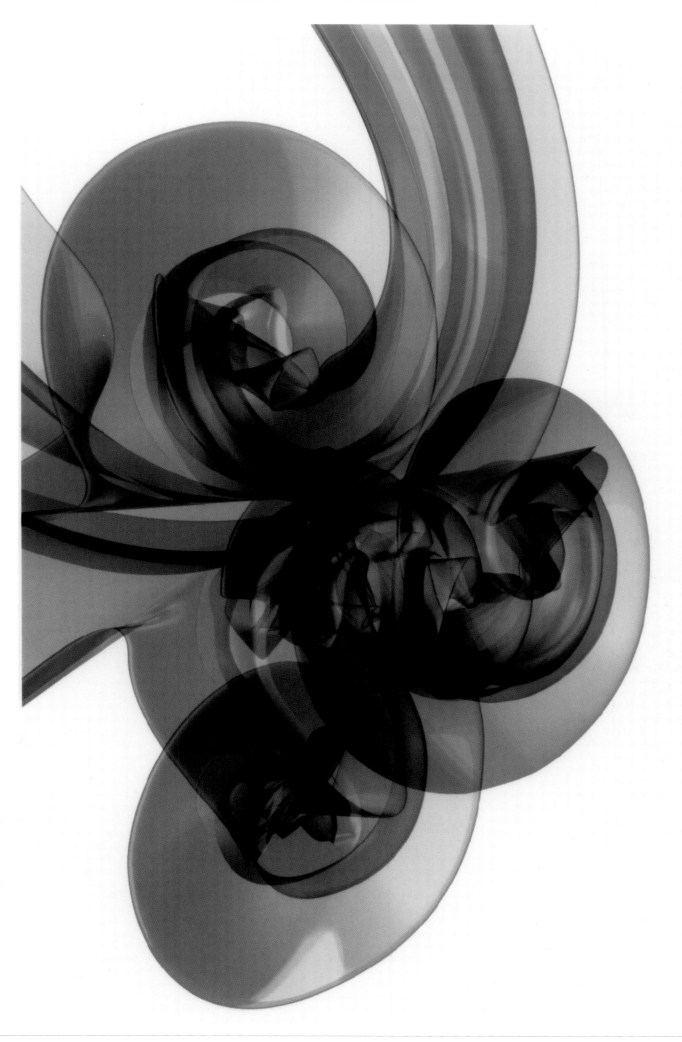

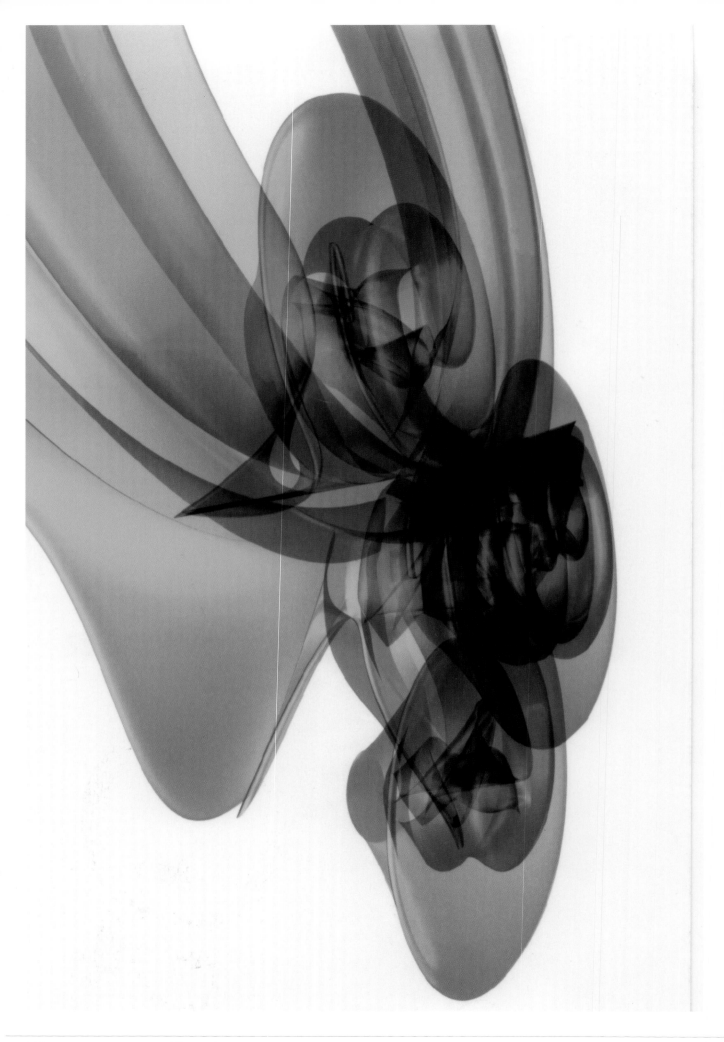

MAD LETTERS

Previous page: "Confused Vortex" (2002), using the typeface Close Ness. The letter used to created this graphic is "G". *Opposite:* "Mad Q Green Phase" (2002), using the font Close Granato. *Above:* "Melancholy Icecube" (2002), using the font Close OGRA Pieces. The word used was "cent".

Dimension

Opposite: "Rigid Spine" (2001), using the typeface Close Ness.
The letter used is "K" (shown at left). *Above:* "Fragile Love"
(2000), using the "division" symbol from the font Close
OGRA Pieces.

TYPOGRAPHIC TERRAINS

Above: "That Time of Month in Greenland" (2000), using the typeface Close OGRA Pieces. The letter used to render the graphic is "M" (*left*). *Opposite:* Design as CD sleeve illustration, "Typographic Environment" (2002) uses the letter "W" from the typeface Porcelain.

UNIFIED THEORY

Page 138: "Petrolian Poo" (2002), uses the letter "B" from the typeface Close Granato. *Page 139:* "Unified Field Theory" (2002), using the letter "Q" from the typeface Close Granato.

BÜRO DESTRUCT

"We think Helvetica is a great font," says Lopetz of Büro Destruct, with a maverick tone in his voice. "We use it all the time." For this five-member Swiss design team, Helvetica is a standard—and indeed, it's an unparalleled font in terms of overall effectiveness. For Büro Destruct, it's a starting point. Apart from all their other graphic design work, this busy team has created a slew of new typefaces over the past few years, which are cataloged on their website www.typedifferent.com.

Büro Destruct's typeface Billding casts the urban landscape of buildings and towers as stacks of words. Heidwig, another Büro Destruct member, explains that this grew from their speculation as to what the world would look like if it were constructed of typefaces. This has led to several three-dimensional experimental models

of urban landscapes, each built with a different typeface. Changing the scale and the dimension of a typeface so that it literally towers over people is a break from the traditional approach to graphics. Büro Destruct's process of designing takes building blocks as a central motif, and then replicates it on a much larger scale. Although the team is based in Bern, the "landscapes" that they create with the blocks are reminiscent of Tokyo; many of Büro Destruct's graphics are inspired by Japanese typography.

This experimentation led to the team's collaboration with various Japanese graphic designers, and eventually to the creation of *Narita Inspected*: a book assembling the work of several of those designers. Thus, although snug Bern may be Büro Destruct's home base, their design ideas and sensibilities reflect a worldliness that diverges from the staid perfection of Swiss design.

bd billding

ABCDEFGHIJKLMNOPQRSTUVWXYZabcdefghijklmnopqrstuvwxyz
90123456789O(!?)(@)
$£%<>"'#$;,.-+·¨

BD BillDing Font & Buildings created and encoded in matte bern.
(c) 2000 buro destruct, bern

Font Billdings

Previous page: Desktop screen for the Büro Destruct typeface Billdings. The towering spires are three-dimensional renderings of the typeface letters. *Right:* Remix of a typographic artwork by Nendo Graphics Japan (originally created for a feature story in the Japanese design magazine *Designplex*).

Typotown

TypoTown is a program created by Büro Destruct to generate typographic "towns." The building blocks for the virtual cityscape are Büro Destruct fonts, which were themselves inspired by form seen in actual towns. The typeface is brought full circle: inspired by forms found in the three-dimensional world, the letterforms serve as the units for a virtual town.

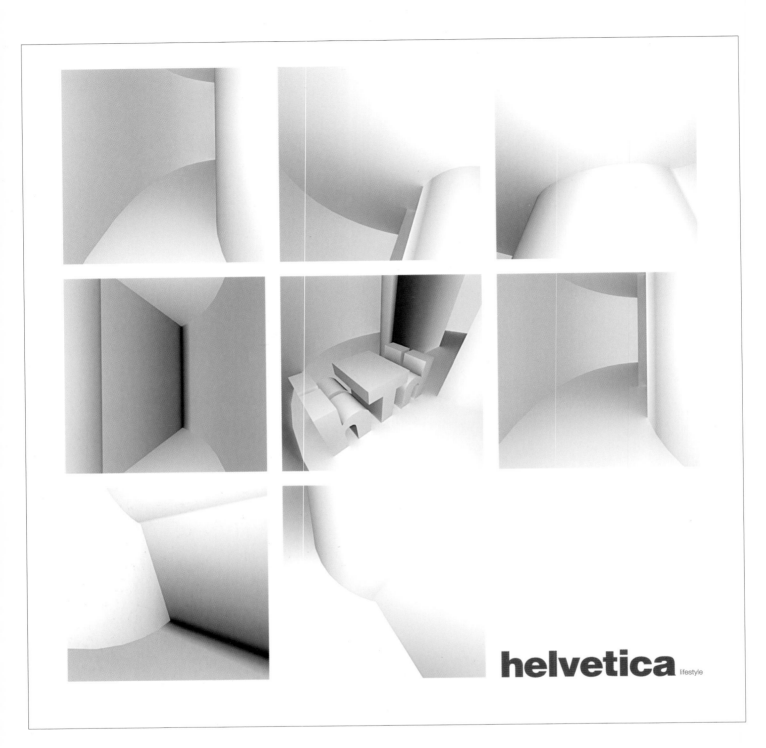

helvetica lifestyle

HELVETICA LIFESTYLE

Above: Virtual furniture inside an extruded letter from the typeface Helvetica. Can you guess which letter was used?
Opposite: Desktop screens for five different Büro Destruct typefaces. (Screens are downloadable at www.typedifferent.com.)

BD Mann
ABCDEFGHIJKLMNOPQRSTUUWXYZAAAAÉÈÈÈÎIÎIÔÔÔÔÜÜÜÜ
abcdefghijklmnopqrstuuwxyzàààèéèèèîîîîôôôôüüüü
1234567890!?\/()\¥C$@7.8'"□→+×;,:-,"¡¿
BD Mann Font was designed and encoded in matte bern switzerland
©2003 büro destruct, bern
www.typedifferent.com
www.burodestruct.net

BD Aroma designed and encoded in bern summer
©copyright 2001 büro destruct Bern Capital
www.burodestruct.net
www.typedifferent.com

BD AROMA

1234567890
ABCDEFGHIJKLMNOPQRSTUUWXYZ
ABCDEFGHIJKLMNOPQRSTUUWXYZ
ÀÖÜ(«&/-_+\<©®û.ß>;,.?!"#>$£¥€)

abcdefghijklmnopqrstuuwxyzàåäöü
CFhklmnopqrstuuwxyz 1234567890
(àû*°$£¥#()/+"(c)_@\?!.;:.«-»)
BD Aric designed and encoded in büro destruct
©copyright 2001 büro destruct Bern Capital
www.burodestruct.net

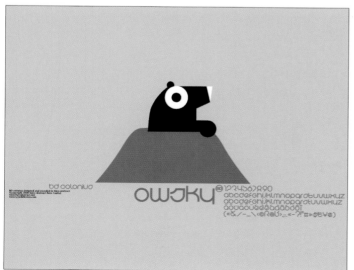

BD Colonius designed and encoded in büro destruct
©copyright 2001 büro destruct Bern Capital
www.burodestruct.net
www.typedifferent.com

bd colonius

owJky ®1234567890
abcdefghijklmnopqrstuuwxyz
abcdefghijklmnopqrstuuwxyz
(«&/-_\<©®û>;,.-?!"#»$£¥€)

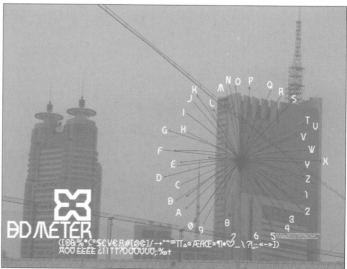

BD METER
([©û&%*°$£¥€ß#[@C]/-+"""∞∏δ%ÆÆŒ=¶•♡_\?!.;:«-»])
ÀÖÜ ÉÈÊË Ł∏∏?ÔÔÔÛÜÜÜ;-%+

NORM

Over the past 2000 years, the one basic structural change that the Latin alphabet has undergone is the creation of the lowercase. Otherwise, the original elements have been passed down unquestioned and virtually unchanged—and they are now, according to the members of Norm, in dire need of an overhaul. This is the task that Swiss design duo Dimitri Bruni and Manuel Krebs have set for themselves.

In the course of generating the 65,000 characters of this experiment, the creation of component parts became automatic. The greater challenge was to select and design characters that are suitable to serve as letters. The criteria that Norm use are: minimal complexity (the fewer strokes required the better); balance; symmetry (which facilitates memorizing) and length (the shorter the sign the better).

The graphics on pages 148–151 are in two grids (one for uppercase and one for lowercase), organizing several of the candidate signs that were considered by Norm for the revised alphabet. The illustrated charts represent permutations of graphic elements that most effectively function as signs in visual communication. The premise is to generate preliminary letterforms using a basic matrix—a base that allows for multiple strokes and shapes. The resulting set of signs is then edited, or selected, by the designers, using the criteria of function and form. Matters such as vertical stability (would the letter tip over if it were a three-dimensional object?) and frequency of a letter's use in a given language, as well as more theoretical concerns (such as the relationship between signifier and signified) are all important.

Letters, then, fall into the category of what Norm calls "Group 2" (all things not in "Group 1," the three-dimensional realm). This second group comprises all representational things, numbers, and data. The availability of technologies—computer software as well as a modern and sophisticated mindset and level of comprehension—is what allows Norm to carry out their sign-generating, categorizing, and subsequent selection. What they have proven for themselves in their research is that letterforms are the end products of multiple generations. A "generation" can either be a run-through of the processing described above, or might refer to something larger: the assumption and development of a writing system over the course of thousands of years.

As a writing system is appropriated from one language into another, the letterforms themselves undergo concomitant changes. This is true of *kanji* (a Chinese writing system adopted by the Japanese), and also of Latin. Influenced by ancient Greek script, Latin implemented a redesign of the Etruscan alphabet, which was itself a redesign of Phoenician script, while the central concept of the Phoenician writing (phonetic script) actually stemmed from the still older Ugaritic writing system. With each redesign, certain elements from other alphabets were integrated, things were appropriated, and others were discarded, in a sort of evolutionary process.

There is thus no specific concept inherent to the Latin alphabet, just as there is no clear advent of its origination. The "designers" of Latin couldn't have known to what end or in what manner the signs would be put to use. The inner structure was created for primitive modes of application, and the letters simply had to be invented and agreed on sooner or later. As the designers at Norm conclude, "We've adapted ourselves to the writing, and not vice versa." Since the birth of the Latin alphabet, Western script has been a given. All devices and machines invented for writing have been subordinate to that script. The language's pervasiveness has made this inevitable.

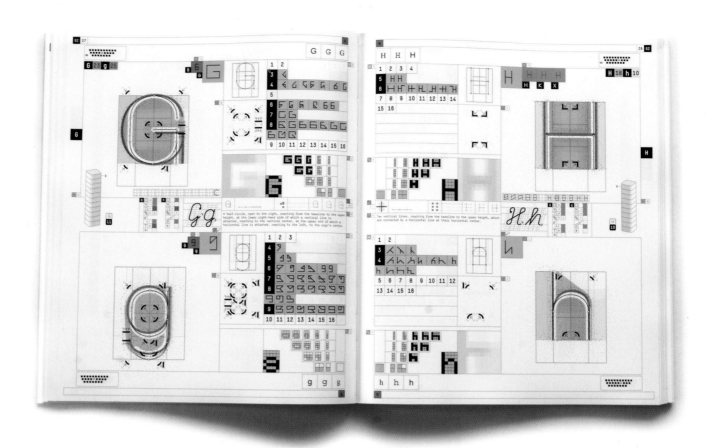

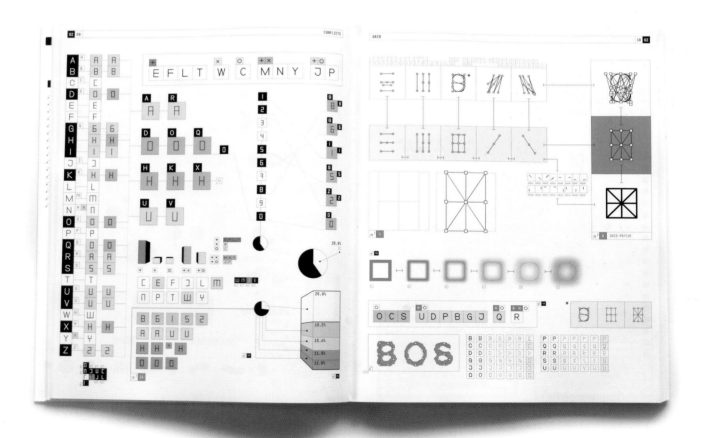

GRID P9/C16

THE THINGS

Previous page: Spreads from the self-published book *Norm: The Things* (distributed by Die Gestalten Verlag, Berlin). Collecting their extensive critical analysis of each of the letters of the alphabet, the design team Norm has evaluated the design integrity of the alphabet as it is known and universally accepted. The topics they broach in their queries are the functionality, versatility, and "graphic durability." Does the form stand strong when exposed to the wear and tear of public use? *Pages 148–151:* The resulting chart of one of their lines of analysis. Here Norm investigated the possible permutations of each letterform to assess whether the most widely used form is truly the most suitable and effective. (This spread, uppercase letters.)

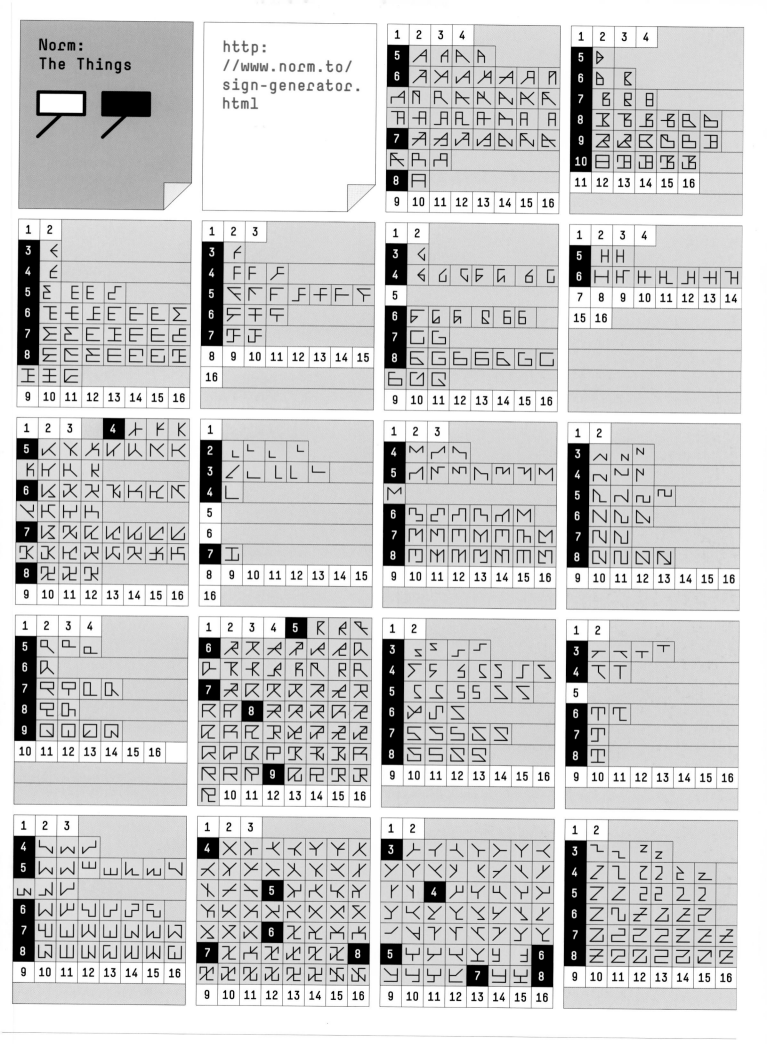

This is the study conducted for lowercase letters. The yellow-colored square in the top row of the chart shows the basic frame used in the experiment to generate each permutation.

Identity

Typography is also a personal matter. The reader brings a lot to a text (personal history, expectation, etc.), all of which influences how things are understood. Similarly, letterforms undergo the same process of "reflecting" the reader. In this section, the work represents several ways of articulating the topic of identity relative to typography. We begin with an English typography and design duo, who incorporate a keen awareness of the self in society into their work. Also, the work of a Scandinavian designer addresses a multiplicity of themes, both cross-cultural and cross-personal. And, finally, a Japanese designer "remixes" the work of an American typographer. We see how a thorough "reading" of a font can be the genesis for a meta-text.

FUNCTION

LICKO + HAYASHI

+ISM

Both members of the design duo +ISM, Matius Gerardo Grieck and Tsuyoshi Nakazako, are expatriates living and working in London. They explain that "the more alien the environment, the more introspective one becomes, and maybe closer to a truer self... [For us], changing location, learning new languages, understanding totally different cultures, and lifestyles, have marked the quest/realization of identity." This sensitivity to their environment informs +ISM's approach. Several of the themes in their work engage with the uncanny—what is familiar is simultaneously unfamiliar, what is trusted is suspect and vice versa.

Consider their hybrid font Aerophobic (pages 160–161). The consistent treatment of the outlined vector graphics here conveys a sense of normality and containment. The graphics of Aerophobic comprise items one expects to find at an airport. But packed in with the travel sundries are surveillance cameras and military guards (with guard dog). The ominous potential for some life-threatening calamity or mass destruction has now passed from being an emotion-driven fear to yet another commonality of travel. Subtle in its way—unless we pay close attention to the details—there is little to alert suspicion here, which, in turn, raises the overall tension.

Among the graphics is an open suitcase containing an explosive device with timer, a pistol and a package of (undoubtedly lethal or narcotic) pills. Like everything in this graphic terrain, it fits neatly into its compartment. There is no aberration, and the ostensible banality can be disturbing if we consider the reality of things. But perhaps what Aerophobic is getting at is the fundamental issue that travel itself has lost any sense of reality. The swift regulation of our environment into modular pieces is an attempt to defray a deeper paranoia and anxiety.

Karoshi (pages 162–163) similarly expresses a complexity of emotions. Chinese characters are organized within a grid system—each character fills a perfect square, with all the component parts organized within this structure. Thus the individual character always maintains some visual balance, both laterally and horizontally. Chinese, like Japanese, is most often set vertically—although horizontal type is also common. Karoshi can be set either vertically or horizontally, with the same overall use of space and organization of the visual plane. To accomplish

this, each letter is made vertically symmetrical. Unlike Chinese characters (based on the square), Karoshi's letters are based on the circle. The name Karoshi (meaning "death by overwork" in Japanese) is both curious and provocative. It is well known that the Japanese have a unique work ethic—often driving employees beyond the limits of physical endurance, frequently leading to hospitalization. Even death, though an exception, can be a consequence of such overwork.

The font—with its strict vertical symmetry, forcing a smooth overall construction—may be seen as the visual expression of what happens in Japanese society. Or, as +ISM puts it, the anxiety to conform and participate in the group is engendered in the individual by the larger structure (the company). Like the font as a whole, the treatment of the individual letters is positively stifling. Thus this type design expands into a social commentary. The underlying questions, which served as the impetus for creating the font, are: "How can one state a 'personal' opinion or critique in a system where individual opinion is frowned upon because priority is given to the collective?" and "How valuable is self-analysis in an environment where self-analysis is almost non-existent?"

Between Grieck and Nakazako, who come from different cultures and ethnic descent, there are many cross-cultural leaps. What is actually being hammered out in their design process are myriad minute, specific expressions. In a sense, responding to larger issues about identity and self is, in fact, a process of answering smaller questions, person to person. The two are constantly aware of their intercultural dynamic, and extremely serious about its implications, not only for their design work but also in coming to terms with fundamental issues of self.

Working with typography and design may provide answers to some questions—but more often the field is rutted with quagmires. For +ISM, making bonds across cultural, racial, and social barriers is a process of uprooting differentiation. What happens therein is the content of most of their design.

1.4 URBAN | 1.3 INFRA

1.0 1.1

1.2 1.3

1.0 ↘ AIR
1.1 ↘ METHOD
1.2 ↘ BRUTE
1.3 ↘ INFRA
1.4 ↘ URBAN

 AK·RO·NYMX · [AC'-RO-NI-mix] -

01· ABBREVIATED KODE RARELY OR NEVER YIELDING MEANING X [XTR. SPECFCTN]
02· WORDS FORMED FROM THE INITIAL LETTERS OF A NAME [ILN], NOW EXPANDED 2 INCL. ANY SERIES OF LETTERS USED TO SHORTEN SERIES OF WORDS [TXTNG]
03· ON THE CORPORATE STAGE : METHOD OF VISUALLY REPRESENTING LANGUAGE REGULATED AS AN ELEMENT OF CORPORATE TRADEMARKS & SYMBOLS [EOCT/S] PATENTED, TRADEMARKED, CONTROLLED, OWNED, REGULATED, AS THE WAY THAT WORDS ARE FORMULATED AS READABLE :
04· AKA 'PHRASING' : PRIMARY TACTICS: CONTENT-EVACUATION [C-E] , TARGETING THE DESIRE OF THE UNCONSCIOUS SELF [D.US] AND THE SIMPLIFICATION OF COMPLEX SOCIAL-RELATIONSHIPS [SCS-R]

1.0 1.1

1.2 1.3

AKRONYMX™
A NU FNT BY MATIUS GERARDO GRIECK

AKRONYMX™ IS A HYBRID
'ALL CAPITALS VARIANT' FONT,
DEVELOPED IN CONSEQUENCE TO HOW
ACRONYM/TEXTING/PHRASING IS
AFFECTING LANGUAGE AS
COPYRIGHTED
STANDARDIZED PROPERTY

AKRONYMX

Designed by Matius Gerardo Grieck. This hybrid typeface uses
the notion of copyright-protected words as its basic concept.

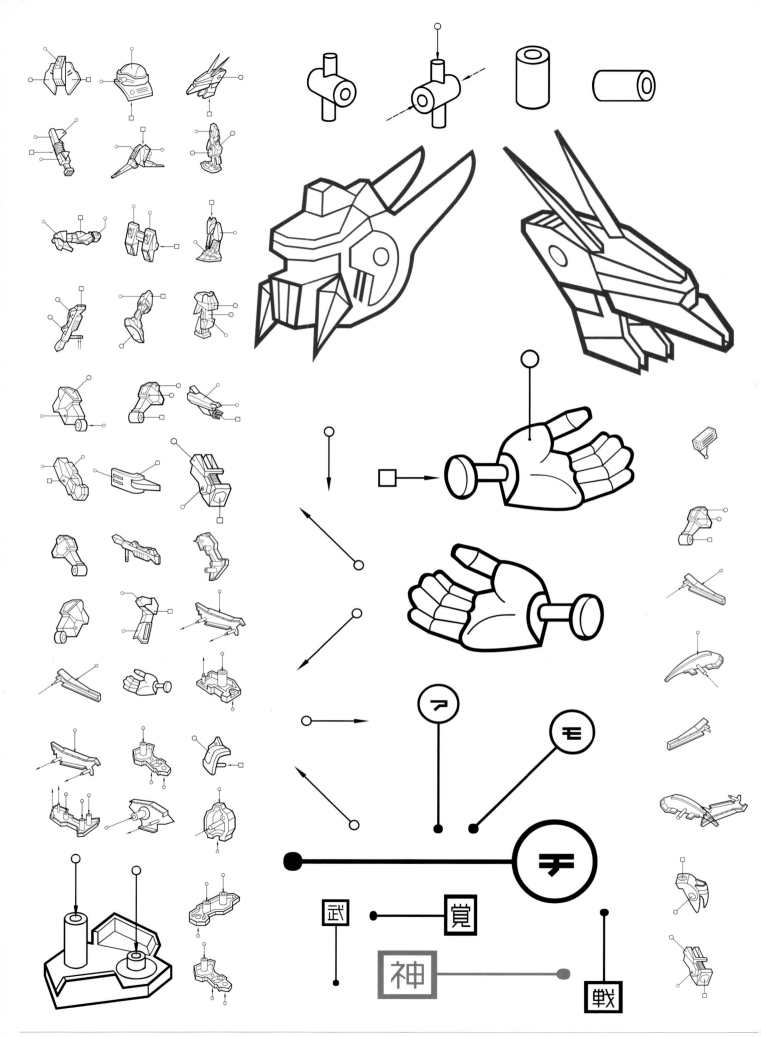

武 覚 神 戦

Bioprosthesis

Designed by Tsuyoshi Nakazako. Each letter has an equivalent
prosthetic. The body parts are not necessarily intended for
the human form but, rather, for an android or half-man/
half-machine creature.

Identity

CORPUS

Designed by Matius Gerardo Grieck, this is another example of
+ISM's hybrid fonts. It is a set of vector graphics that comprise
one complete font.

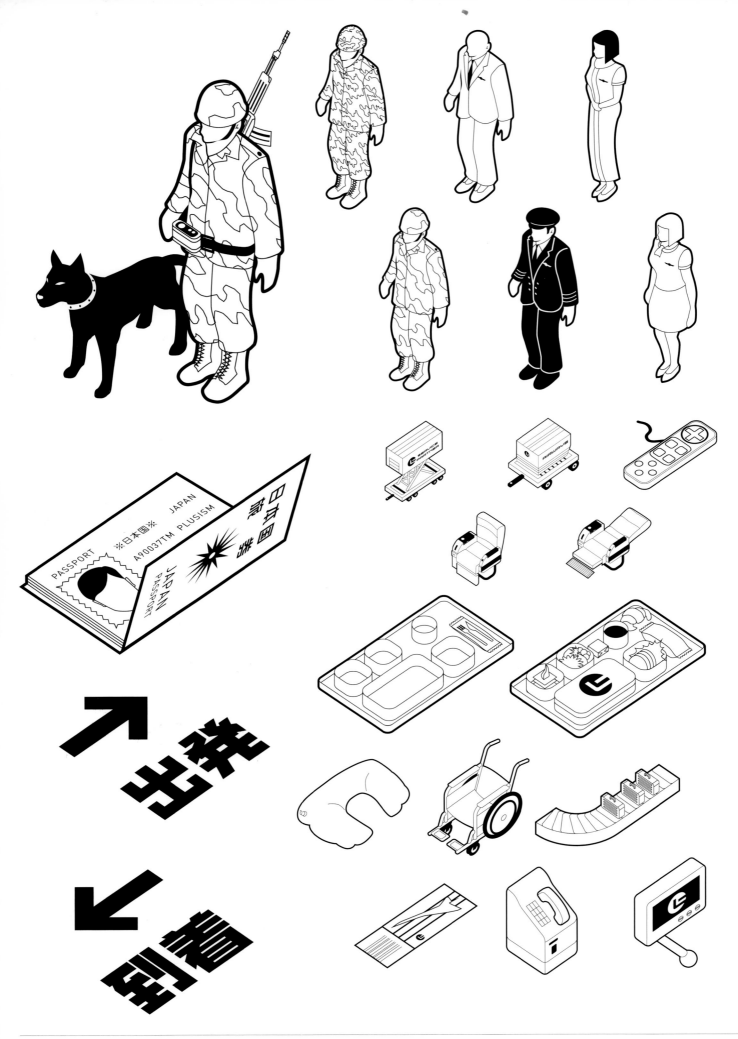

AEROPHOBIC

Graphic set designed by Matius Gerardo Grieck. Luggage claim
tickets, in-flight meals, and motion sickness tablets are no more
routine than surveillance cameras and hidden weapons.

KAROSHI

Meaning "death by overwork", Karoshi is an indictment
of Japanese culture and its inability to make room for
personal expression.

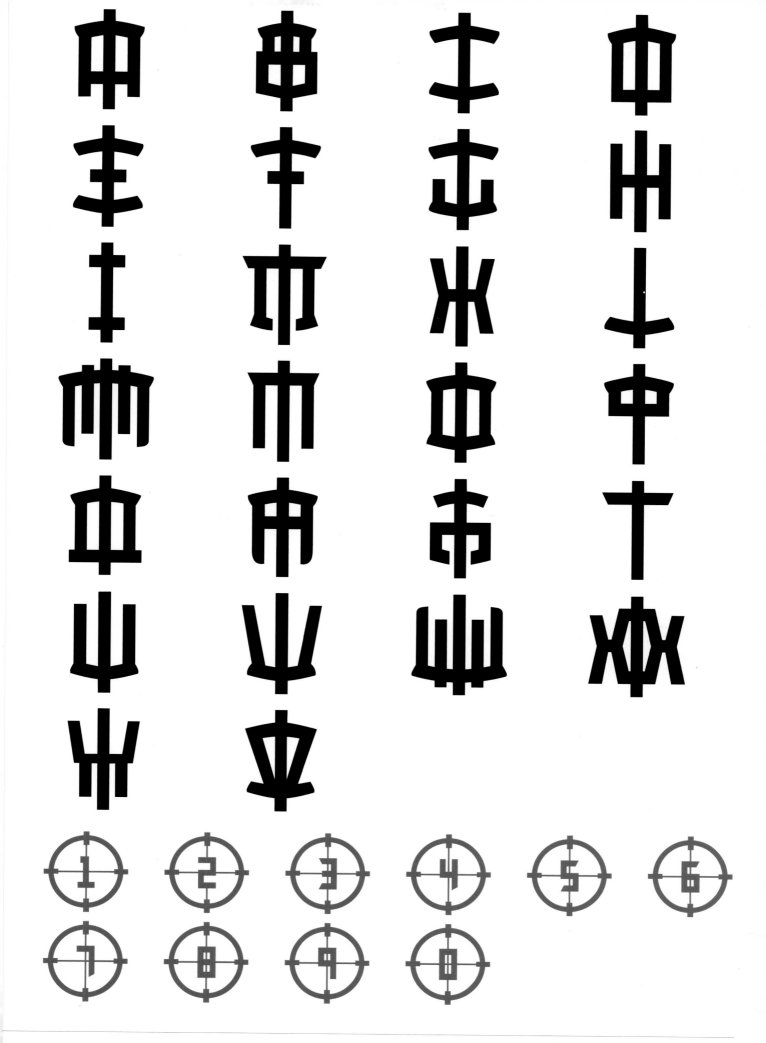

7PT LAB

As the diagram (*left*) illustrates, these fonts are created on a base grid. These fonts are intended for extremely small display on the computer screen. In order to maintain legibility at such small sizes (in terms of memory as well), the grid is relied upon. However, the limitation has been the springboard for extremely inventive type design. *Above:* Neopath 1.0. *Opposite, above:* Hypertexturian 1.0. *Opposite, below:* the *katakana* face of the Transhuman family.

YOU ARE BEAUTIFUL

The curiously named website www.youarebeautiful.co.uk is a portfolio site for designer-typographer Kerry Roper. The convoluted imagery of Roper's designs might be a frustrated response to his daytime profession in advertising, but it is also part of his general creative style, which is largely characterized by a process of layering. In Roper's work, dimension and the build-up of the graphic itself gloss the individual layers like a digital patina. In the center of illustration Graphic Hooligan (page 172), for example, is a photograph that is almost entirely obscured by a red stencil. The photograph, Roper explains, was pasted onto a wall in a public place, and surreptitiously painted over by someone else in an attempt to obliterate the image of two men kissing.

As in the work of designer Jonathan Barnbrook or of artist Jean-Michel Basquiat—both of whom drew attention to words and visual elements by crossing them out—here the photograph under the stencil demands and receives our full attention, even if it may be difficult to discern what is going on. The stenciling that is placed over the image is, in a sense, a poetic reduction of all the rhetoric that surrounded the image.

Roper's locale, London, is an important source of his inspiration. Buildings provide a veritable museum of visual stimulation, exhibiting a barrage of torn posters, graffiti, markings, advertisements and other signage. Similarly, the type compositions of Roper's graphics seem to be on a par with the mish-mash of visual elements cluttering the images. The words themselves are clipped, and abut one another and the graphics with no apparent discretion (pages 174–175). The letterforms are gnarled in the process, as are the words and expressions. This is, of course, a reflection of how things truly are in the world: so few of the words we see actually get read. Roper's graphics present an "unedited recording" of found words. Their interrelation is like that of snippets of conversation overheard on a train—interrupted by distractions, with the rumbling sound of the train adding a thick layer of white noise to the entire composition.

Perhaps Roper's work is most effective in its linking of graphic elements with type; where the two are out of balance, the composition points out the supremacy that letterforms wield over their graphic cognates. The eye is quick to tease out the letterforms, and diligently gets on with its task: to read.

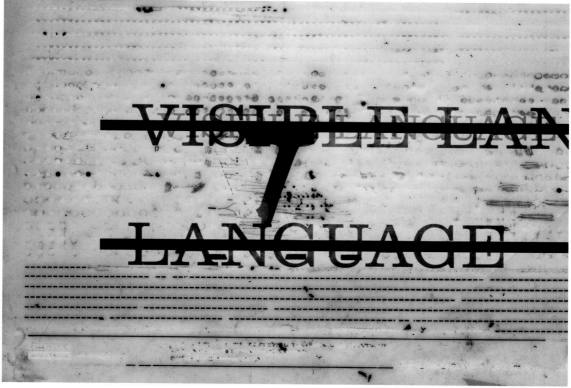

Visible Language

Above and right: The designer combines image and letterforms in
these type design experiments.

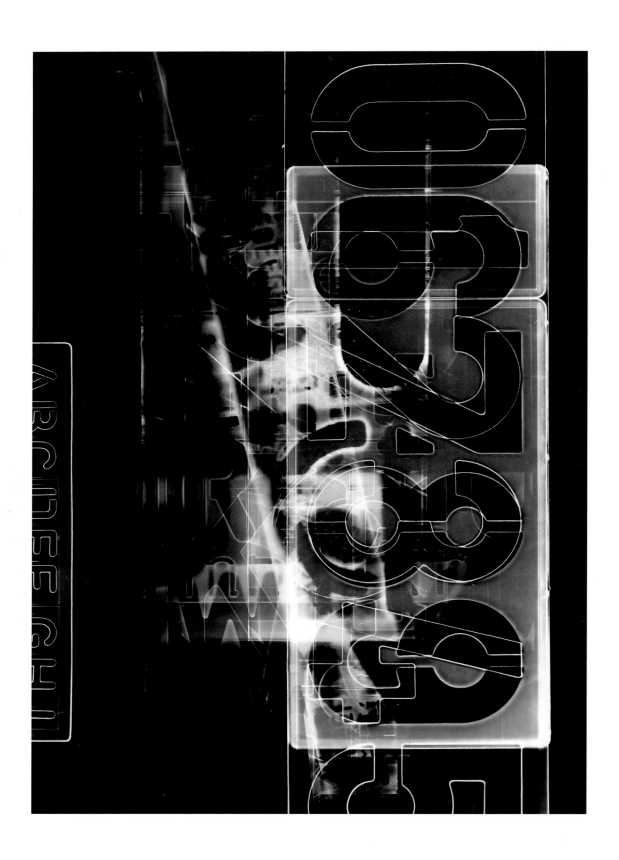

Identity

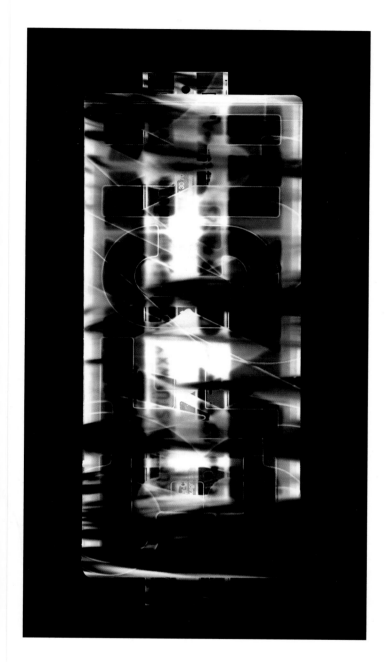

STENCIL EXPERIMENTS

This spread: Manipulated images of letter stencils.

FUSIONS

This spread: Type design experiments using type and image.

Below: Graphic Hooligan. The first layer (*left*) includes a
photograph that the designer Roper found pasted onto a wall.
Layered onto this is a clear lettering stencil. The process of
layering is complete with the addition of his type treatment
(*above*), thus demonstrating the "patina-like" nature of word
function. *Opposite:* Illustrations for *Computer Arts* magazine.

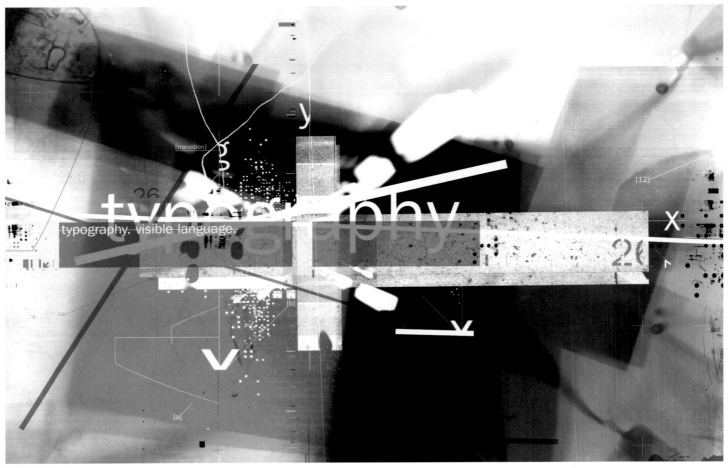

TRANSFER

Opposite, above: An illustration demonstrating the navigational capabilities of the software Flash 4. *Opposite, below:* An illustration for *Computer Arts* magazine. *Above:* The designer mixes photography and desktop type design with Letraset dry-transfer lettering.

FUNCTION

The typefaces on pages 178–183 were designed by Function, an Oslo-based Norwegian design group with Halvor Bodin, Marius Watz and Kim Hiorthøy. Bodin maintains that there is no such thing as a "Scandinavian graphic style," as designers are mostly urban and, by extension, international in outlook.

But if the spirit of a nation can be summed up in statistics, Bodin provides this picture of Oslo, Norway (a country of 4.5 million people): "Per annum we have 1,916 hours of sunshine and 143 days of precipitation... and 672 robberies/blackmail incidents. Outside of the Protestant state-church of Norway, there are 24,455 Muslims and 5,391 Buddhists. Fatalities by cause per year: 11 murders, 57 by alcohol abuse, 88 suicides, and 97 by substance abuse. 9.2 percent of citizens are non-Norwegian. Number of cars: 180,199. The quantity of milk marketed by the dairy Fellesmeieriet per annum in Oslo: 77,475 liters. So, we are basically suicidal, milk-drinking, white Protestants living outside the European Community. We are rich and we are proud; we have oil and we have mobile phones; we have government support of the arts. We are approaching the millennium in a state of gluttony."

A font group that Function designed in 1997 is a reflection of this state of affairs. The fonts are dubbed F This Is Where The Dog Is Buried and Bonusfont F Shinjuku. They were created for the typography magazine *Fuse*, in an issue titled *Echo* edited by Neville Brody and Jon Wozencroft. Following the journal's theme, Bodin took as the basis for his fonts the echo as used in sonar devices. In the search for oil, echoes bring back readings from the sea's floor; thus the first font weight is called Bottom of the Sea. The second weight, Top of the Mountain, is a collection of symbols spanning icons of Norwegian heritage—some wholesome, some derelict, some prosaic: sailing vessels, traditional dress, paperclips.

These two font weights suggest the dichotomy of a nation seen from within and from without. This dichotomy might also be applied to Oslo (an "international" urban center) versus Norway (a larger, more nationalistic entity). The "within" and "without" is thus paralleled (or "echoed") in the contradistinction between a major city and a larger community—as between individual and nation.

GOETHE

A B C D E

F G H I J

K L M N O

P Q R S T

U V W X Y

Z 1 2 3 4

5 6 7 8 9

a b c d e

f g

h i

j h

STOCKMARKET

Designed by Halvor Bodin, Stockmarket takes its inspiration from the German wax-crayon manufacturer Stockmar. The crayon-maker closely follows the color theory (the color circle) of Johann Wolfgang Goethe, which synthesizes a unified understanding of the inter-relationship of colors and their effects on the viewer, from a physiological perspective as well as the "sensory/moral" effect of colors on the mind and soul. Bodin explains that Stockmarket draws on these notions and puts them into play with commercial design "focusing on the contradictions/similarities of ethics, aesthetics and commerce."

Identity

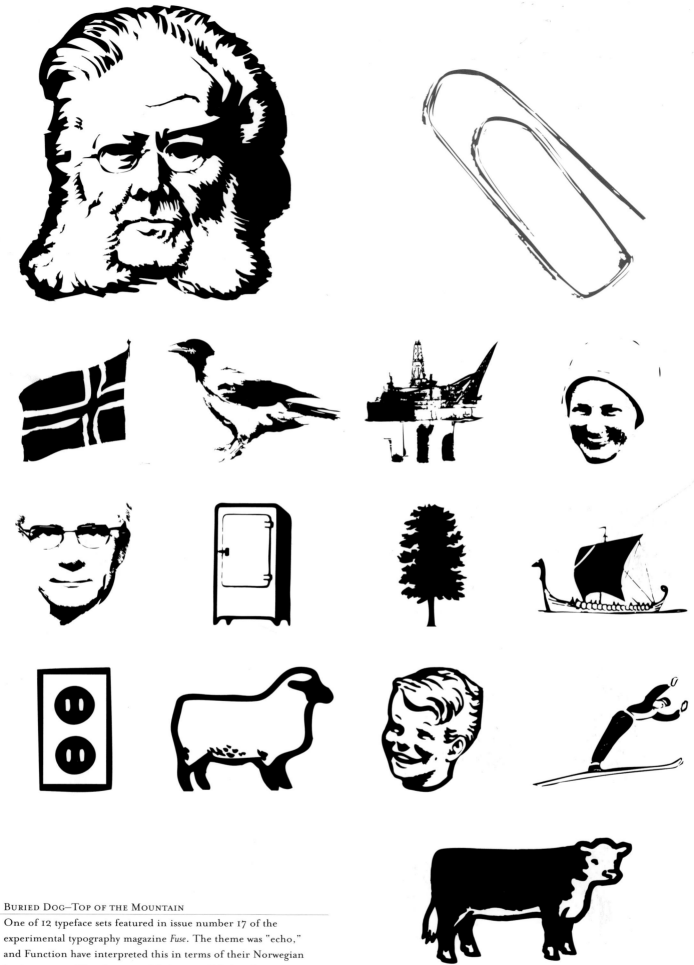

BURIED DOG—TOP OF THE MOUNTAIN

One of 12 typeface sets featured in issue number 17 of the
experimental typography magazine *Fuse*. The theme was "echo,"
and Function have interpreted this in terms of their Norwegian
heritage, assembling iconographic images of their culture
(including the paperclip).

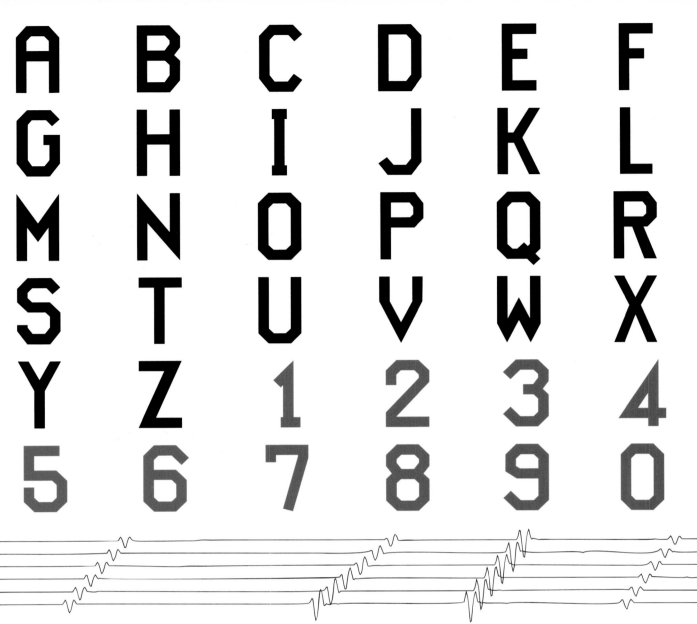

SHOT.TRC

BURIED DOG—BOTTOM OF THE SEA
Another typeface set contributed to *Fuse* issue 17, Bottom of the Sea uses images related to sonar, an "echo" used for scanning the depths of the sea.

2.39

TIME (SECS)

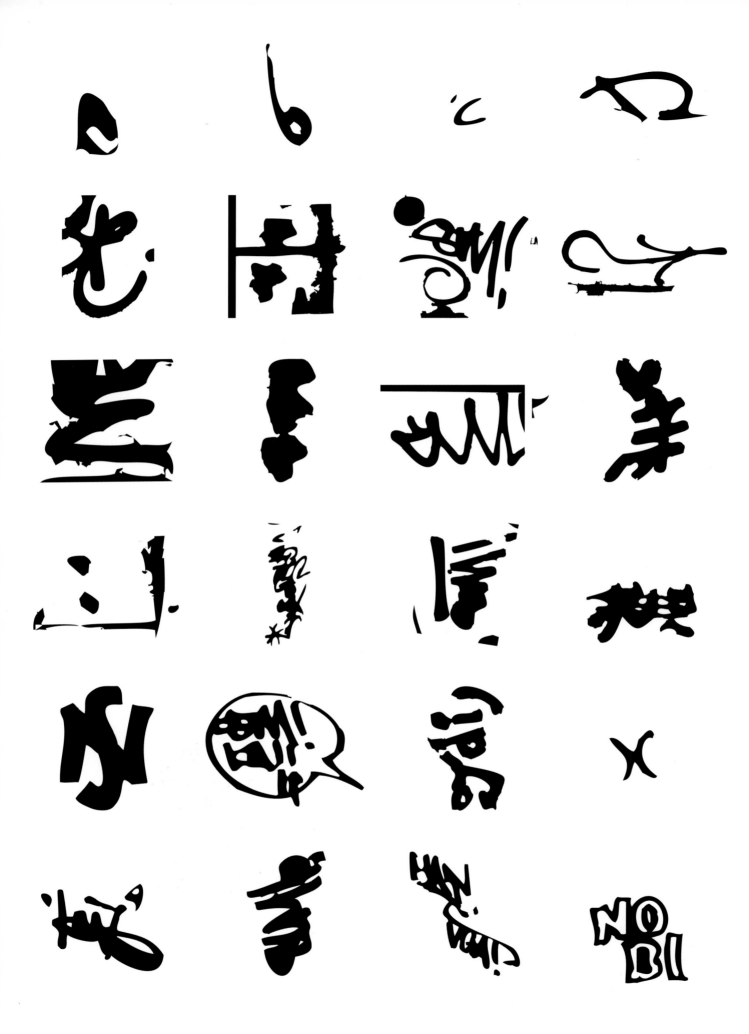

Identity

SHINJUKU

Designed as one of the typefaces contributed to *Fuse* issue 17, Shinjuku has little to do with Function's native land. Rather, the typeface is a dingbat assembly based on the graffiti and hip-hop culture found in one of Tokyo's urban districts.

LICKO + HAYASHI

Japanese designer Shuzo Hayashi created the six patterns shown on pages 186 to 191. They were made using two Emigre typefaces, Hypnopaedia and Whirligig, both designed by Slovakian-born typographer Zuzana Licko. Hypnopaedia is itself an amalgam of several different Emigre fonts (some of which were originally designed by Licko as well). By connecting individual letters for each character of Hypnopaedia, Licko came up with a secondary set of letters (or motifs) based on the primary faces; each motif is symmetrical, both laterally and vertically. Whirligig is a dingbat character set. In combining the two faces (or character sets), Hayashi initiated a process of questioning and resolution.

Licko created patterns using these typefaces, and after several years working with Hypnopaedia and Whirligig as separate design elements for several projects, Hayashi, too, decided to try working with patterns. He was disappointed with his first pattern, not with the elements themselves, but because the resulting motif itself lacked, as he puts it, a "sense of now" in its repetition. This first pattern is the repetition of two letters in succession. This "phrase"—ABABAB—could in theory be repeated *ad infinitum*. But it is also a closed system, complete and self-generating, and in this sense, the pattern was lacking in something that is specific to any particular time, especially now. Release from such a system would break the repetition, thus affecting the here and now. This, then, was Hayashi's challenge: to find the way out of the closed circuit of the pattern. This pursuit was the basis

for the subsequent five patterns. Eventually, he made patterns with longer phrases: ABCDABCDABCD. New layers added a complexity to the motif that ostensibly escapes predictable repetition, as demonstrated in Hayashi's sixth pattern. Within each phrase of the pattern there is a moment of chaos, now-ness and release—despite the fact that the pattern is still made up of a closed set.

Licko's creation of Hypnopaedia and Whirligig is interpreted by Hayashi as bordering on chaos within systems. Viewing Licko's work in this manner similarly sheds some light on the nature of typography—which is itself a closed system of phonemes represented by letters. Again we find ourselves in a box. It may be a bit larger, the phrases generated more extensive, and the extent of the combinations may exceed necessity—but it is still a closed system.

Shodou (Japanese calligraphy) masters found themselves faced with the same issue. They were also in pursuit of nuance within the system of language. Hayashi draws a parallel between Hypnopaedia and the Japanese syllabary, which derives from Chinese characters. Both systems result from a process of reworking characters and letters. And Hayashi maintains that both were generated from a single source: chaos and its clash with order.

Hypnopaedia (ca. 1997) and Whirligig (ca. 1994) are licensed by Emigre.

SHIFTING PERSPECTIVES

The patterns reproduced on pages 186–191 were created for
the boxes, as in the examples above. Designer Hayashi explains
that when two-dimensional patterns were put on the boxes,
the images on the flat surfaces were "set into motion." With
the change in perspective, the patterns (and their component
graphics) become shifting shapes. The size and shape of the
box also determines what segments—or "phrase"—of a pattern
are visible. In other words, there is a specific relationship
between size and form. Lastly, only three faces of these
three-dimensional structures can be viewed at any one time.
This allows the pattern to repeat itself *ad infinitum*.

PATTERN NUMBER ONE

Above: The first of six patterns designed by Hayashi, using two typefaces designed by typographer Zuzana Licko: Whirligig and Hypnopaedia. *Left:* One of the 152 illustrations in Whirligig.

PATTERN NUMBER TWO

Above: The second of six patterns designed by Hayashi, using two typefaces designed by typographer Zuzana Licko: Whirligig and Hypnopaedia. *Right:* A four-unit arrangement of one of the illustrations from Hypnopaedia, which has 140 illustrations in total.

PATTERN NUMBER THREE

Above: The third of six patterns designed by Hayashi, using two typefaces designed by typographer Zuzana Licko: Whirligig and Hypnopaedia. *Left:* For this Hypnopaedia illustration Licko uses the letter "Y" from the typeface Democratica, designed by Miles Newlyn (*Emigre,* ca. 1991).

PATTERN NUMBER FOUR
The fourth of six patterns designed by Hayashi, using two
typefaces designed by typographer Zuzana Licko: Whirligig and
Hypnopaedia. *Right:* A four-unit arrangement of one of the 152
illustrations in Whirligig.

PATTERN NUMBER FIVE

Above: The fifth of six patterns designed by Hayashi, using two typefaces designed by typographer Zuzana Licko: Whirligig and Hypnopaedia. *Left:* For this Hypnopaedia illustration Licko uses the letter "O" from the typeface Matrix Script, also designed by Licko (*Emigre*, ca. 1992).

PATTERN NUMBER SIX

Above: The last of six patterns designed by Hayashi, using two typefaces designed by typographer Zuzana Licko: Whirligig and Hypnopaedia. *Right:* For this Hypnopaedia illustration, Licko uses the number "5" from the typeface Filosofia, also designed by Licko (*Emigre,* ca. 1996).

The author would like to extend his humble thanks to each of the contributors to this volume for their patience and good faith, as the book progressed through several incarnations over the past couple of years. It is a testament to the strength and caliber of their work that the selection included in this volume has stood the test of time and remained as fresh as when I first encountered it. Several individuals provided key insights that were helpful to the initial formation of the book, namely: Rico Komanoya, typographer Hideaki Ootani, Wendy Byrne, Shuzo Hayashi, Kyoko Wada, Jennifer Purvis, and Lesley A. Martin. James Booth-Clibborn of Purple House, Patrizia Crivelli of the Swiss Federal Office of Culture, and Carole Guevin of netdiver.net were kind enough to share their thoughts on noteworthy typographers. Diana Stoll's deft and sensitive copyediting with the original manuscript has been the sounding board to complete my thoughts and the grounding to make my writing readable. The patience and dedication of the RotoVision team is immeasurable. Thanks to my publisher Aidan Walker. His strong vision and persistence has facilitated the formation of the book in its present form. Luke Herriott, RotoVision's art director, provided invaluable guidance with the book's design and layout, thereby greatly improving the clarity of presentation of the materials reproduced in this volume. The history of this book is long and convoluted but thanks to that I've had the good fortune to work with a succession of gifted editors at RotoVision: Kate Shanahan, Leonie Taylor, and Zara Emerson. A special thank you to Ms Taylor and Ms. Emerson for their valorous efforts in expertly pulling together the final manuscript under phenomenal time constraints. And, finally, a "mini" thank you to Joe Gillespie of www.minifonts.com.

TypoGraphics: The Art and Science of Type Design in Context was created, produced and authored by IVAN VARTANIAN / GOLIGA BOOKS, TOKYO, INC.

Production
RICO KOMANOYA

Editors
KATE SHANAHAN
LEONIE TAYLOR

Text Editors
ZARA EMERSON
DIANA C. STOLL

Book Design
IVAN VARTANIAN

Jacket and Cover Design
GARY FRENCH / ROTOVISION

The typeface used throughout this publication is Mrs Eaves, designed by Zuzana Licko (Emigre), ca. 1996. The Helvetica family is used for headline and display copy.

Other titles by Ivan Vartanian / Goliga Books:
Andy Warhol: Drawing and Illustrations of the 1950s (2000)
Egon Schiele: Drawings and Watercolors (2003)

Also forthcoming from RotoVision:
"Graphiscape" series (2003)